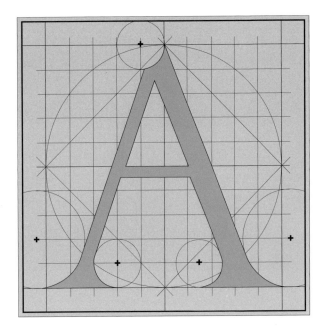

ALPHABET

The History, Evolution, and Design of the Letters We Use Today

Allan Haley

WATSON-GUPTILL PUBLICATIONS / NEW YORK

The text on pages 18–63 is based on a series of articles entitled "The Letter" that originally appeared in *U&lc* magazine. Courtesy of International Typeface Corporation.

Copyright © 1995 by Allan Haley

Published in 1995 in the United States
by Watson-Guptill Publications,
a division of BPI Communications, Inc.,
1515 Broadway, New York, N.Y. 10036

Library of Congress Cataloging-in-Publication Data
Haley, Allan.
 Alphabet: the history, evolution, and design of the letters we use today/Allan Haley.
 p. cm.
 Includes index.
 ISBN 0-8230-0170-9
 1. Type and type-founding—History. 2. Alphabet—History. 3. Calligraphy. I Title.
 Z250.A2H17 1995
 686.2'1—dc20 94-39682
 CIP

Manufactured in the United States of America

First printing, 1995

1 2 3 4 5 6 7 8 9 / 03 02 01 00 99 98 97 96 95

Senior Editor: Candace Raney
Edited by Joy Aquilino
Art direction and design by Jay Anning
Calligraphy on pages 64–67 by Janet Prescott Fishman
Graphic production by Ellen Greene

This book was a long time in coming. Years passed between the time I wrote "The Letter A" article for *U&lc* magazine and when I finished the last chapter for my publisher, Watson-Guptill. As a result, there are many people to thank for their support, direction, and encouragement.

In addition to the many readers of *U&lc* who expressed their enthusiasm for the subject by writing to request reprints of the articles that became the foundation of this book, there are the scholars of typography and chirography (calligraphy) who forged a path for me to follow. I would also like to thank Ed Gottschall, who gave me the idea to write the *U&lc* articles and helped me improve them.

I am indebted to my friends and family, who may not have understood why a book about the alphabet was so important to me, but who were nonetheless always kind, patient, and supportive.

Finally, recognition is due to Jay Anning, who designed this book and made the words beautiful, and to Joy Aquilino, the most professional and insightful editor I have worked with—if you like this book, much of the credit is hers.

SPECIAL THANKS
Special thanks are due to Adobe Systems and Font Haus for providing many of the fonts that became part of the design of *Alphabet*. These two companies are shining examples of how art and commerce can be mutually supportive and enriching.

CONTENTS

INTRODUCTION

Writing and pictorial art evolved from the same human impulse—to represent and depict things, concepts, and events, and by doing so to somehow possess and dominate an otherwise enigmatic and indomitable world.

Writing is words made visible. In the broadest sense, it is everything—pictured, drawn, or arranged—that can be turned into a spoken account. The fundamental purpose of writing is to convey ideas. Our ancestors, however, were designers long before they were writers, and in their pictures, drawings, and arrangements, design played a prominent role in communication from the very beginning.

The Latin alphabet began as simple forms scribed with reed or stylus. Today these same letters are constructed in electronic bits. All of the alphabets shown in this book were created with design software on a computer terminal. While some are modern interpretations of typefaces created over 500 years ago and others mimic the strokes of the calligrapher's brush, the lineage of nearly all our letters can be traced to the earliest Phoenician letterforms of 1500 B.C.

Alphabet is about the history and design of the Latin alphabet—the very letters you are reading. It is intended for those who work with, design with, or just want to learn a little more about the letters of our alphabet. I wrote *Alphabet* simply because I love letters, and delight in their sensual forms and communicative potential. If the basis of all writing is the desire to tell, then *Alphabet* is my account of the history, beauty, and power of letters. It describes how the monumental capitals (the alphabet inscribed on ancient Roman monuments and architecture) evolved from their earliest pictorial ancestors to the letters we use today. It is also about the history of our lowercase alphabet, the origin of our numbers, and why our punctuation looks the way it does. In addition, *Alphabet* is about how these characters are created so that their proportions are correct and their forms pleasing. For those readers who are new to the subject of typography, I have provided an overview of type classifications and a glossary of the terms that are used throughout the book. The profusion of type specimens that illustrate this book are presented to stir your imagination, whet your creative appetite, and delight your eye.

I wrote *Alphabet* for the fun of it. It is my hope that you read it for the same reason.

ALLAN HALEY

A SYSTEM OF CLASSIFICATION

Most text typefaces can be classified into one of two groups: those with serifs and those without. Over the years, in order to further categorize typeface design traits, several more definitive systems were developed, some with over a hundred different categories. While two broad categories of type are inadequate for understanding the full extent of typographical development and diversity, hundreds can be self-defeating. In what is hoped to be a reasonable compromise between the two extremes, the system of classification that follows utilizes nine basic groups, some of which have been subdivided further for added clarity. While there may be some differences between this and other type classification systems, as well as disagreements concerning the placement of a typeface or two, the intent here is to provide a set of working guidelines for the typographic communicator—with an emphasis on the word "guideline." The good news is that few things typographical can be rigidly defined, fostering the potential for healthy debate and leaving those who relish the finer points of type unimpeded by an inflexible system of standardized models.

OLD STYLE

The first roman types, old style faces were created between the late fifteenth and mid-eighteenth centuries, or are patterned after typefaces that were designed during that period. In these designs, the axis of curved strokes is normally inclined to the left, so that the weight stress falls at approximately eight and two o'clock. The contrast in character stroke weights is not dramatic, and hairlines tend to be on the heavy side. Some versions, like the earlier Venetian old style designs, are distinguished by the diagonal cross stroke of the lowercase e. Serifs are almost always bracketed in old style designs, and head serifs are often angled.

VENETIAN

These are the first of the old style faces, created in Venice around 1470. They generally take their style and proportions from handwritten letters drawn with an obliquely held broad-nibbed pen. A dead giveaway for Venetian old style designs is the diagonal cross stroke of the lowercase e; almost every example has one. Venetian old style faces also have very minor contrast in stroke thickness and their serifs are heavily bracketed. Some typical designs are Bauer Text, Centaur, Cloister, Cloister Old Style, Deepdene, Kennerly, and Italian Old Style.

Deepdene

ALDINE

Aldine old style designs are based on the original work of Aldus Manutius during the early 1490s. During the sixteenth century these models were adopted and emulated first in France, then throughout Europe. (It is probably one of the first typefaces to have undergone widespread duplication—sort of the Helvetica of its day.) These typefaces generally have more contrast in stroke weight than Venetian old style designs, and the crossbar of the lowercase e is almost always horizontal. Serif bracketing is also obvious, but usually not as pronounced as in earlier designs. Among Aldine old style designs are Bembo, Garamond, Goudy Old Style, Palatino, Sabon, and Weiss Roman.

Bembo

DUTCH

In the Netherlands, the larger x-height, darker color, and enhanced contrast in stroke weight of the German blackletter were melded with Aldine design traits, resulting in Dutch old style designs. This style first appeared in the mid-sixteenth century, but continued to be developed and refined well into the twentieth. These are heavy types that tend to be exceptionally legible and readable. Caslon, Concorde, Janson, and Plantin are just a few examples.

Allegory

Janson

REVIVAL

There are two catchall categories in this system, one of which is the revival group of typefaces. These may display a predominance of old style design traits, but are generally not patterned after any particular type of the period. Many times, in fact, they share several design influences. As with

other old style designs, however, character stroke width and contrast are relatively conservative, weight stress is inclined, and serifs are bracketed. The revival category includes designs such as ITC Benguiat, Cooper Black, ITC Galliard, ITC Garamond, Italia, Raleigh, ITC Tiffany, Trump Mediaeval, ITC Weidemann, and Windsor.

Cooper Black

TRANSITIONAL

The style for these typefaces was established in the mid-eighteenth century, primarily by the English printer and typographer John Baskerville. His advancements in paper-making and printing allowed much finer character strokes to be reproduced and subtler character shapes to be maintained. While the axes of curved strokes are usually inclined, they generally have a vertical stress. Weight contrast is more pronounced than in old style designs, though the serifs are still bracketed and the head serifs oblique. These typefaces represent the transition between old style and modern designs, incorporating characteristics from both categories. Included in this group are Baskerville, Caledonia, Fairfield, Perpetua, ITC Usherwood, and ITC Zapf International, as well as many others.

Allegory

Baskerville

MODERN

The work of Giambattista Bodoni in the eighteenth century epitomizes this style of type. Modern type designs, when they were first released, were referred to as "classical." Early on, however, it became apparent that these were not updated versions of classic type styles, but altogether new ones. As a result their designation was changed to "modern"—which they in fact were at the time. Here, contrast between thick and thin strokes is abrupt and dramatic, and the axes of curved strokes is vertical with little or no bracketing. These tend to be highly mannered designs that are obviously constructed, rather than drawn. Moderns are plagued by the dreaded typographic disease of "dazzling," in which the strong vertical stress creates a "picket fence" appearance that tends to vibrate on the page. These are the aristocrats of type: beautiful to look at, though somewhat unapproachable.

DIDONE

Setting the standard for all other modern type designs, Didone typefaces were created during the eighteenth century, or are directly descended from those designs. Didones normally have slightly heavier hairline strokes than twentieth-century moderns. Some have slight, almost imperceptible serif bracketing; however, most do not, and the serifs themselves are generally not much more than simple hairlines tacked on to the ends of vertical strokes. In many cases, stroke terminals end in a ball shape rather than the type of end stroke

created by a broad-nibbed pen. Typical Didone designs include Bauer Bodoni, Bodoni, Didot, and Torino.

Bauer Bodoni

TWENTIETH CENTURY

These typefaces were created during the twentieth century, and while they may share many design traits with Didones, they were generally not intended as revivals of those earlier designs. Twentieth-century moderns also tend to be more stylized than their predecessors. ITC Fenice, Franklin Antiqua, Linotype Modern, ITC Modern No. 216, Berthold Walbaum Book, and ITC Zapf Book are among the many twentieth-century modern type designs.

Allegory

ITC Fenice

CLARENDON

This style of type first became popular in the 1850s. Like the Didones before them, Clarendons have a strong vertical weight stress, but this is their only similarity. While Clarendon designs have obvious contrasts in stroke thickness, they are not nearly as dramatic as in the Didones. In addition, serifs in Clarendon designs are normally heavy, bracketed, and usually square-cut. These are the typographic workhorses: robust designs that can tackle virtually any task with predictably successful results. They aren't espe-

cially attractive or sophisticated, but they get the job done.

NINETEENTH CENTURY

As their name implies, these were the first Clarendon type styles to be released. Their stroke weight contrast is the least pronounced of all the Clarendons, and their serifs tend to be short to medium in length. Many of these designs were initially released as display types, and relatively few made the transition from foundry to machine-set type. Bookman, Cheltenham, and Cushing Antique are typical nineteenth-century Clarendon typefaces.

Allegory

ITC Bookman

NEO-CLARENDON

These typefaces are more sophisticated twentieth-century renditions of the first Clarendon designs, the next evolutionary step from display to text. Contrast in character stroke weight is more obvious, and the serifs tend to be longer. Some of these typefaces share design traits with other categories as well. A few characteristic neo-Clarendons are ITC Century, Century Schoolbook, ITC Cheltenham, ITC Korinna, and Melior.

Allegory

ITC Century

CLARENDON/LEGIBILITY

First released in the 1920s, these type designs are the final link in the Clarendon evolutionary chain. Contrast of stroke weights is minimal, serifs are generally on the short side, and x-heights are usually large. These typefaces were specifically designed to be highly legible and easy to read in a variety of typographic environments. Though generally not noted for their dazzling design, they are the hardest working of the Clarendons. Clarion, Corona, Excelsior, Ionic No. 5, Nimrod, and Olympian are just a few examples.

Excelsior

Slab Serif

Slab serif typefaces have very heavy serifs with no, or exceptionally slight, bracketing, and variations in stroke weight are virtually imperceptible. To many type designers and aficionados alike, slab serif typefaces are essentially sans serif designs with the simple addition of heavy (stroke-weight) serifs. Slab serif designs are exceptionally durable and tend to evoke a sense of simplicity and sincerity when set as text, and also serve as very versatile display designs. Some typical slab serif designs are Aachen, Egyptienne, ITC Lubalin Graph, Memphis, Rockwell, Serifa, and Stymie.

Serifa

Glyphic

Typefaces in this category tend to reflect the influences of lapidary inscriptions rather than those of pen-drawn forms. Contrast in stroke weight is usually minimal, and the axis of curved strokes tends to be vertical. The distinguishing feature of these typefaces is the triangle-shaped serif, which in some glyphic faces is modified to a flaring of the character strokes where they terminate. In some type classification systems this category is divided into two groups: glyphic and Latin (the ones with precise, triangle-shaped serifs). Among the many glyphic designs are Albertus, Friz Quadrata, ITC Novarese, Poppl-Laudatio, Romic, ITC Serif Gothic, and ITC Veljovic.

Allegory

Friz Quadrata

Sans Serif

Simply put, these typefaces have no serifs. (The French word *sans* means "without.") Although stonecut versions of this style predate the development of movable type, a sans serif design was first cast into type in 1816 by William Caslon IV (a descendant of William Caslon, who designed the important serif typeface that bears his name). Aside from their lack of serifs, the most distinctive quality of sans serif typefaces is their tendency toward an optically monotone stroke weight, a trait that some typophiles feel hinders their effectiveness in text composition, even more so than their lack of serifs. Because they were generally viewed as ugly, early sans serif types were called "grotesques," a designation that is still used in England.

GROTESQUE

These are the first commercially popular sans serif typefaces. In sans serif grotesque styles, contrast in stroke weight is notably apparent, there is a slightly "squared" quality to many of the curves, and several

designs have the "bowl and loop" lower-case g common to roman types. In some cases the R has a curled leg, and the G usually has a spur. These are the "personality" types of the sans serif category—some even have a kind of homespun quality. Alternate Gothic, Franklin Gothic, News Gothic, and Trade Gothic are just a few examples.

News Gothic

NEO-GROTESQUE

These sans serif designs are patterned after the first grotesques, but are more refined in form. Stroke contrast is less pronounced than in earlier designs, and much of the "squareness" in curved strokes is also absent. Neo-grotesques can easily be confused with their earlier counterparts. Usually the distinguishing characteristics of these faces are their single-bowl g, accentuated monotone weight stress, and lack of personality. The neo-grotesque category of typefaces includes Akzidenz Grotesk, Folio, ITC Franklin Gothic, Haas Unica, Helvetica, Imago, Univers, and Video.

Allegory

Helvetica

GEOMETRIC

Simple geometric shapes heavily influence the construction of these typefaces. Their strokes have the appearance of being strict monolines, and character shapes are comprised of seemingly perfect geometric forms. Geometric sans serif faces tend to be less readable than grotesques. Typical geometric designs include ITC Avant Garde

Gothic, ITC Bauhaus, Bernhard Gothic, Erbar, Futura, Kabel, Metro, and Spartan.

Allegory

Futura

HUMANISTIC

Of all the sans serif typefaces, these most closely duplicate roman design characteristics and proportions. As they are based on the proportions of Roman inscriptional capitals and lowercase letters, this is clearly intended. In many cases, contrast in stroke weight is readily apparent, reflecting a strong calligraphic influence. Many type designers assert that these are the most legible and most easily read of the sans serif types. Clearface Gothic, Cosmos, ITC Eras, Frutiger, Gill Sans, Optima, Praxis, Syntax, and Vela are some typical humanistic sans serif typefaces.

Allegory

Gill Sans

SQUARE

Square sans serif designs are generally based on grotesque or neo-grotesque character traits and proportions, but exhibit a distinct (and at times dramatic) squaring of routinely curved strokes. They usually have more latitude in character spacing than their sans serif cousins, and tend to be exceptional display designs. Antique Olive, Letraset Compacta, and Eurostile are just a few examples.

Allegory

Eurostile

SCRIPTS

Available in a wide range of shapes and sizes, script typefaces seek to imitate cursive writing. Some are very elegant and appear to be carefully drawn with a quill pen, while others express the essence of spontaneity. (In the interest of expediency and efficiency, I have grouped all scripts under one category; to do justice to them over a dozen subcategories would have to be covered.) Typical of the category only in the diversity of their design, Coronet, Legend, Medici Script, Mistral, Poppl-Exquisit, Snell Roundhand, and ITC Zapf Chancery are representative scripts.

Allegory

ITC Zapf Chancery

GRAPHIC

The second catchall category in this classification system, graphic typefaces defy simple pigeonholing. They might look like they were cut in stencil, created on a computer terminal, or decorated with flowers. Their only shared trait is that they are plainly constructed rather than based on written forms. Some of these typefaces are excellent communicators, others are not. In fact, some pretty thin excuses for type design fall into this category, none of which are represented in this book. ITC Benguiat Gothic, Britannic, ITC Isbell, Lo Type, Parisian, and Revue are some of the more subdued examples of this group.

Revue

TYPOGRAPHIC TERMINOLOGY

Arm: A horizontal stroke that is free on one or both ends.

Ascenders: The parts of the letters b, d, f, h, k, l, and t that extend above the height of the lowercase x.

Baseline: The imaginary line on which characters rest. DESCENDERS fall below the baseline.

Bold or **boldface:** A heavier rendition of the standard or roman version of a typeface.

Bowl: A curved stroke that encloses a COUNTER, except the lower portion of the two-storied lowercase g, which is a LOOP.

Calligraphy: A writing style based on the strokes created with a flat-nibbed pen or a flat brush.

Cap line: An imaginary line that runs along the top of a line of capital letters.

Characters: Individual letters, numerals, punctuation marks, and other elements of a typeface.

Character set: The letters, numerals, punctuation marks, and special characters that constitute a font.

Condensed: Classification of a typestyle in which the letters are narrower than normal.

Counter: Fully or partially enclosed space within a letter.

Cross bar or **cross stroke:** The horizontal stroke of the e, f, t, A, H, and T.

Cursive: Typefaces resembling handwritten script. See also CALLIGRAPHY.

Descenders: The parts of the letters g, j, p, q, and y that extend below the BASELINE.

Display type: Type that, by means of its size or weight, is used to attract attention; usually 14 points or larger.

Ear: The small stroke projecting from the right side of the upper bowl of the lowercase g.

Em space: The square of a given point size of type, which varies in size and width, depending on the typeface's proportions.

En space: Half the width of an EM SPACE.

Expanded: Classification of a typestyle in which the letters are wider than normal.

Hairline: The thin stroke in a serif typeface design.

Headline: Usually the most prominent element of type in a piece of printing; that which attracts the reader to read further or summarizes at a glance the content of the copy it accompanies.

Italic: Type in which the letters are obliqued. Cursive typestyles are usually italic, but not all italics are cursive.

Leg: The bottom diagonal on the uppercase and lowercase k.

Ligature: Two or more characters linked together as a single glyph.

Link: A stroke connecting the upper bowl and lower loop of the lowercase g.

Light or **lightface:** A lighter rendition of a standard or roman version of a typeface.

Lining figures: Numerals that are the same height as the capitals in any given typeface and align on the BASELINE. Also called uppercase figures.

Loop: The lower portion of the lowercase g.

Lowercase: Small letters or minuscules. Coined during the days of hot metal composition, this term refers to the cases that were used to hold the individual pieces of type, which were arranged in two sections, one higher than the other. The capitals were kept in the upper part of the case and the small letters were kept in the lower part of the case.

Lowercase numbers: See OLD STYLE FIGURES.

Old style figures: Numerals that vary in size, some having ascenders and other descenders, normally corresponding to lowercase proportions. Also known as lowercase numbers.

Roman: Name generally applied to the Latin alphabet as it is used in English and European languages. Also used to identify upright, as opposed to italic or cursive, alphabet designs.

Sans serif: Typestyles without serifs.

Script: Type designed to suggest writing with a brush or pen.

Serif: A short, terminating stroke that is usually perpendicular to the main stroke of a character.

Shoulder: The curved stroke emerging from a stem.

Small caps: Capital letters whose height is approximately the X-HEIGHT of the typeface. Normally available in text designs only.

Spine: The main curved stroke of the capital and lowercase S.

Spur: A small projection from a stroke.

Stem: A prominent vertical or diagonal stroke.

Stress: The direction of thickening in a curved stroke.

Swash letters: Characters with fancy flourishes, usually provided as alternates.

Tail: The part of the Q that differentiates it from the O, or the diagonal stroke of the R that distinguishes it from a P.

Terminal: The end of a stroke not terminating in a serif.

Text: The body copy in a book or on a page, as opposed to the HEADLINE.

Text type: Main body type, usually set in type smaller than 14 points.

Typeface: One of the variations of styles in a type family, such as roman, italic, bold, ultra, condensed, expanded, outline, contour, and so on.

Type family: A range of typeface designs that are all variations on one basic style of alphabet. The usual components of a type family are ROMAN and ITALIC, combined with variations of weight (LIGHT to extra BOLD). Type families can also include variations in the width of the letterforms (CONDENSED or EXPANDED).

Uppercase: Capitals; see LOWERCASE.

Uppercase figures: See LINING FIGURES.

x-height: The height of a typeface's lowercase characters, excluding ascenders and descenders. So named because it is based on the height of the lowercase x.

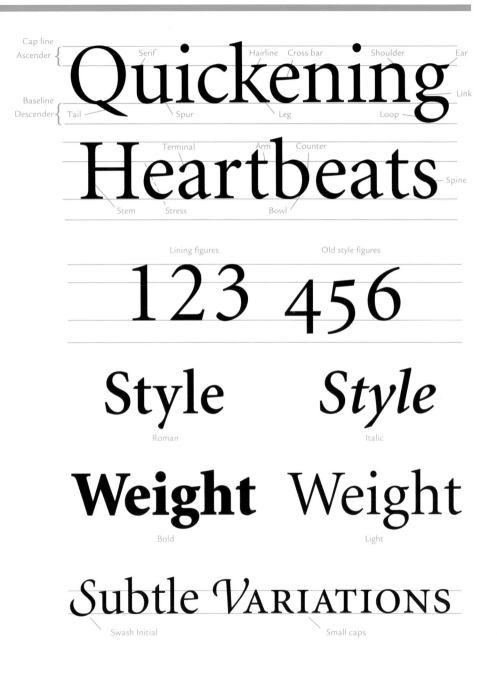

THE CAPITAL LETTERS

It began quite simply. The precursors of the first attempts at writing consisted of simple tokens: a flower left outside someone's hut to express a tender message, or a pile of rocks along a trail to warn of danger. Slowly, these tokens and signs evolved into marks. The marks that began the enterprise of writing had to be easily understood, well designed, and sufficiently recognizable so that they could be linked to the same meaning again and again. From its conception, writing was an art.

The first graphic images were generally very simple shapes that represented a rather basic vocabulary: man, woman, fire, food, tree, shelter, and other fundamental things and ideas. Gradually, more symbols were needed to express more words and concepts, so, for example, a number of "tree" symbols were unified to make a "forest," or the symbols for man, woman, and child were consolidated into a single "family" symbol.

The difficulty of writing with symbols is plain: It takes too many symbols to express complicated and sophisticated language. As human culture and society became increasingly complex, propelled by the mechanisms of agriculture, religion, and politics, graphic forms of expression were developed to respond to their demands. Earlier symbol writing referred to specific things or ideas, making it inadequate for expressing abstractions, keeping records, or creating documents. To surmount these obstacles, new writing systems required a reduction in form as well as an expansion of meaning.

The Egyptians were probably the first to develop an elaborate system of symbol writing, which later became known as hieroglyphics (Greek for "sacred writing"). They began by using pictures to represent words and syllables with the same or similar sound (rebus writing). Over thousands of years they gradually began to use pictures to represent syllables (phonograms, or sound pictures), which they strung together to create words. In time they created hieratic and demotic scripts, simpler forms of writing that were used for religious and commercial documents. This set the stage for the creation of alphabets throughout the nation-states encircling the Mediterranean.

The next evolutionary step was brought about by the Phoenicians, the forerunners of modern entrepreneurs. They clearly had a need for an alphabet, but not for the graceful, decorative alphabet of the Egyptians. The Phoenicians were concerned with record keeping, and little else. As a result, Phoenician writing was free of frills, easy to read, and quick to write. Phoenician writing was also purely alphabetic—each character corresponded to one sound. Through the process of doing business in Greece, the Phoenicians also passed on their alphabet. Once again our alphabet's distant ancestor changed—the Greeks added vowels, new characters, and attractive curves—and its beauty began to take shape.

The Latin alphabet was derived from Greek letterforms by way of the Etruscans, a people indigenous to the Italian peninsula. The Romans adopted and adjusted the Greek alphabet in the same confident way they adopted and adjusted to the rituals of the Greek gods, by developing their own style and characters based on the Greek foundation.

The Roman capital letters are the formal letterforms that were carved into monuments and buildings and used for important manuscripts. Although they were carved in stone, the Roman capitals reflect the same principles as handwritten letters. Our typefaces possess curves and have thick and thin stroke gradations because the structures of their Roman forebears were based on the forms created with flat-nibbed pens. The Roman capitals have had, and still have, the greatest influence on the design and use of capital letters, enduring as the standard of proportion and dignity for almost two thousand years.

Until about A.D. 800, changes in our alphabet were both gradual and evolutionary. There were no clear-cut lines of demarcation in design development. This changed when Charlemagne ascended the throne of the Holy Roman Empire in 771. Charlemagne undertooka far-reaching revival of learning and civic betterment. One of the results of this heroic undertaking was the development of a consistent writing style. The Caroline minuscules, as they have come to be known, were the prototypes of our own modern small letters. They are important not only because they are a permanent manifestation of genius, but because they furnished models for lowercase printing types used to this day.

These two standards, the Roman capitals and the small letters that evolved from the Caroline minuscules, provided the basis for letterforms when movable type was invented by Johann Gutenberg. As the Renaissance unfolded, Griffo, Jensen, and Garamond used them as models in the fifteenth and sixteenth centuries. This standard was maintained in the eighteenth century in the work of John Baskerville, and has continued well into the twentieth, with the type designs of Frederick Goudy, Hermann Zapf, and Matthew Carter. Although attempts have been made to tamper with letterform designs—to condense them or expand them, to equalize their varying widths, to electronically change their proportions—the consequences have not replaced the design principles set by the Romans and affirmed by their successors. They have become the quintessential melding of art and information.

Why is A the first letter of our alphabet? One source states that it is because this letter represents one of the most common vowel sounds in the ancient languages of the Western hemisphere. Other equally learned sources would argue against this rationale because there were no true vowel sounds represented in the Phoenician language. Why is A the first letter? No one really knows. Why does A look the way it does? No one can be certain of this answer either, and educated guesses tend to dominate the telling of the tale. A reasonably logical chain of events, however, can be reconstructed.

It is said that the Phoenicians chose the head of an ox to represent their *a* sound (actually, a glottal stop). The ox was a very common, and very important, animal to the Phoenicians. As the main power source for the Phoenician's heavy physical

work, oxen plowed the fields, harvested crops, and hauled food to market. Some sources even claim that the ox was also the main course at many a meal. A symbol for the ox would have been the perfect Phoenician logo for food. Since food tops the "human needs" list, it (somewhat) naturally follows that an ox symbol would also be the first letter of the alphabet.

The Phoenicians first drew the ox head glyph signifying the *a* sound as a V with a crossbar to distinguish the horns from the muzzle. The letter was called *alef*, the Phoenician word for ox. Through centuries of writing (most of it quickly, with little attention to detail), the alef evolved into

something that evolved into something that bore little resemblance to the original ox head symbol. In fact, by the time it reached the Greeks in about 400 B.C., it looked more like our modern lowercase k than a capital A.

The alef further evolved in the hands of the Greeks, who had no idea that it was supposed to look like an ox. First they rotated it 90° so that it pointed up; then they drew the crossbar as a sloping stroke. Finally, the crossbar became a horizontal stroke so that the character that resulted looked almost as it does today. The Greeks also changed the name of the letter from alef to *alpha*.

The Romans acquired the Greek alphabet through their dealings with the Etruscan traders of what is now northern Italy, and again changed the name of the first letter, this time to *ah*. The long *a* sound, the sound used as the name of the letter A in English, was not prevalent in the Latin language.

Latin Extra Condensed

Copperplate Gothic 30

Aachen Bold

Shelley Allegro

AG Old Face Shaded

Futura Light

Helvetica Black

In his story of "How the Alphabet was Made," Rudyard Kipling relates a very different—and charming—account of the genesis of the letter A. In Kipling's story, the alphabet was invented by a Neolithic hunter and his daughter. While traveling with her father one day, the daughter got the notion that it would be useful to be able to leave notes and send messages. She asked her father to make a sound, and he said, "Ah!" The daughter decided that her father looked liked a carp feeding when he made that sound. She then drew a fish to represent it, but since she was not a good artist and a little impatient (as children tend to be), she drew only the fish's head.

When her father saw the drawing he said that it could be mistaken for the head of almost any fish, so he proceeded to add the feeler that hangs across the carp's mouth.

His daughter copied the finished drawing, again impatiently, not adding all the details. Her drawing looked like this:

And thus, according to Kipling, the first letter of our alphabet was born.

The width of the capital A should be approximately three-quarters of its height. In virtually all roman designs the first stroke of the A is lighter than the second—in most cases a hairline. Look closely at sans serif designs like Helvetica or Franklin Gothic and you will notice that this trait has been incorporated to an almost imperceptible degree.

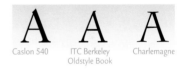

Unless it has a flat top, the apex of the A should protrude slightly above the normal cap height. This is an optical adjustment that keeps the letter from looking short.

While the crossbar is normally placed below the actual center of the character to prevent visual distortion, it can be moved above or below the optical center to achieve a desired effect, or to inject personality into the character.

A University Roman
Letraset Pleasure
Bold Shaded A

Type designers should know, however, that the more personality a letter has the more it is limited to display applications. For example, if a high crossbar

creates a small counter, the character may not only look awkward but the counter may also begin to fill in at text sizes. The A's crossbar is also almost always horizontal, but in some alphabets it is curved or inclines slightly.

Some As have a top serif, which is usually an extension of the right diagonal stroke beyond the intersection with the left diagonal. Caslon and ITC Clearface are good examples. A few typefaces have a top serif that angles in the opposite direction, to the right. ITC Berkeley Oldstyle is such a design. Some designs, like Charlemagne or Italia, have a serif that is a horizontal stroke crossing the apex of the two diagonals.

A A A
Caslon 540 ITC Berkeley Charlemagne
 Oldstyle Book

In most roman designs the outer baseline serifs are longer than the inner serifs.

Cooper Black

Notre Dame

Letraset Dolmen

Adobe Garamond
Italic Alternate

Stencil

THE LETTER

B

Most people consider shelter the second most important ingredient for human survival. B, the second letter of our alphabet, evolved from the ancient Egyptian hieroglyph signifying shelter. Although the designs are somewhat different, there is a recognizable correlation between this glyph and the second letter of the Phoenician alphabet, which evolved from it, and which the Phoenicians called *beth,* which means "house." The name of this letter is discernible in various place names referred to throughout the Bible, including Bethel ("house of God") and Bethlehem ("house of bread").

While the name change was relatively minor, the Greek beta that eventually emerged looked quite different from the Phoenician beth. These structural changes took place gradually, over the course of many years. First the character was inverted so that the triangle sat at the base. Then, perhaps because symmetry was so important to the Greeks, a second triangle was added and the two triangles ended up on the right side of the character.

The Greek beta further evolved in the hands of the Romans, who changed its name to *bā* and, more importantly, formalized the curved strokes.

inherited the precursor to our current alphabet, they were using flat-nibbed pens and flat brushes to draw their letters on smooth writing surfaces. The result was the beautifully proportioned letters we are now familiar with. It has been shown that even the inscriptions on Roman monuments were first painted on with a type of flat brush before they were carved. These letterforms were so proportionally compelling, and at the same time so precisely legible, that they serve as a guide to type designers even today.

From the Phoenician square "house," the B grew into one of the most beautiful letters of our alphabet.

Arnold Böcklin

Bank Gothic Light

Bauer Bodoni

The beth was one of the nineteen characters that the Greeks acquired from the Phoenician traders and subsequently adapted as the basis of their own alphabet. In the process, they changed the name of the letter slightly, from beth to *beta,* and in doing so provided us with the second half of the two-letter name that makes up the word *alphabet.*

The Romans were some of the first calligraphers in the Western world. They brought flowing lines and graceful curves to our alphabet. It was art born of technology. The early Greeks drew their letters by scratching through a soft wax coating applied to a wooden board, which forced them to work primarily in short, straight lines. By the time the Romans

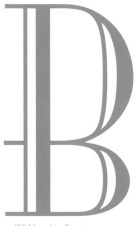

ITC Mona Lisa Recut

Bodega Sans Black

The width of the B should be about half, or a little more than half, its overall height. The top bowl emanates from the vertical stem at an angle, while the bottom swings from the stem in a graceful curve. The top bowl in roman designs will sometimes meet the bottom at about one o'clock on its curve. It is a common mistake among novice type designers to make the top and bottom bowls the same size—the bottom bowl should almost always be larger. Optically, this gives the character a feeling of balance and stability. In some designs, such as Weiss, the bottom bowl may appear to be smaller than the top one. This is a fine balance, because if it were actually smaller it would look out of proportion. In some faces, like Belwe and ITC Benguiat, the lower bowl is markedly larger than its top.

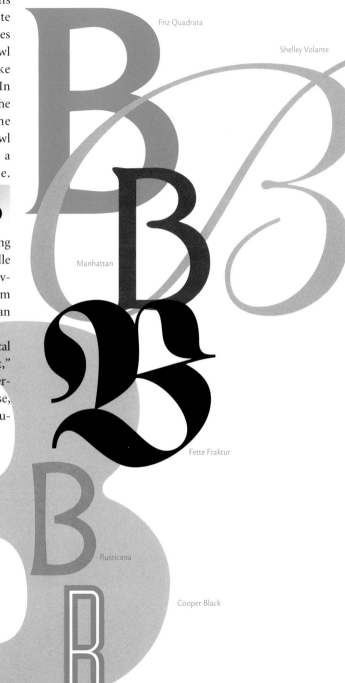

In roman typefaces the bowls are widest slightly above the center of each curve.

Normally, the two bowls are joined by a hairline stroke that appears parallel to the baseline and connects to the main vertical stroke. There are some type- faces, however, in which this hairline stroke does not quite meet the vertical, or continues the curve of the bottom bowl and joins the vertical stroke above its optical midpoint. In ITC Souvenir, for example, the bottom bowl attaches to the bottom curve of the top bowl rather than sharing with it a common horizontal stroke.

Also in the interest of creating an optical balance, the middle hairline should be slightly heavier than the top, and the bottom hairline just a little heavier than the middle.

In roman designs the vertical stem may have a slight "waist," which is the narrowing of a vertical stroke. If this is the case, the bottom of the stem is usually heavier than the top.

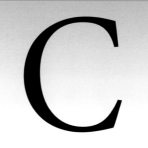

For much of their history, the letters C and G evolved as the same character. The Phoenicians called it *gimel,* which means "camel," and used it to indicate the sound roughly equivalent to the *g* sound in the word "gate." They drew the character with two quick diagonal strokes, creating something that looked like a very broad inverted V with one stroke shorter than the other.

When the Greeks began to use the Phoenician gimel in their writing, they took many liberties with its original design. First, they reduced the angle between the two strokes so that the new letter resembled an upside-down capital L with the arm extending to the left. Then they reversed it so that the short stroke was on the right side. This trend toward design-reversal was a common Greek approach to the Phoenician letterforms they adopted. In fact, several characters met with this fate. The reason probably lies in the fact that the early Greeks, for some time, wrote *boustrophedonically* (from the Greek word *boustrophedon,* which means "turning like oxen in plowing"). Although the Greeks initially had observed the Phoenician custom of writing from right to left, later they wrote and read the characters of alternate lines in opposite directions, which meant that nonsymmetrical letters were reversed in alternate lines. By the sixth century B.C. the Greeks had abandoned the boustrophedonic style of writing in favor of the practice of reading and writing consistently from left to right, but by that time many letters had been permanently inverted from the original Phoenician designs.

As they had done with other Greek letters, the Romans softened the sharp angle of the *gamma* to a curve, and the resulting form looked very similar to our C.

The Romans used this letter to indicate both the unvoiced stop *c* (as in "cat") and voiced *g* (as in "gate") sounds, and in time they distinguished the two sounds graphically as well. The unvoiced stop continued to be expressed by the original C design, and a barb was added to the bottom terminal to indicate the voiced *g* sound.

Thus, the gimel evolved into both the C and the G. The C is not only the third letter of our alphabet, it is also the first to share the same design for both capital and lowercase versions.

Ariadne

Futura Light

Smaragd

Goudy Text Lombardic Capitals

ITC Kabel Ultra

Charlemagne

Lunatix Light

If you think of the C as an O with part of its right side missing, you should take a closer look. Imagine instead that the letter is being fashioned from a bar of iron, so that as the two arms of the resulting horseshoe are pulled apart, its top and bottom would be flattened slightly. This gives the C a firm foundation on which to rest and helps propel the eye forward as it moves across a page of text. The bottom terminal also normally extends just a little beyond the top one to give the character optical balance.

The width and height of the C should be approximately the same. As with other round characters, a typeface's C should also be a little taller than the height of its H. This, and a slight increase in stroke weight, ensures that it will not look comparatively light or small. In some designs the C is also imperceptibly shorter than the O because the open space on the right side of the letter tends to exaggerate its size slightly.

In a roman alphabet whose C is designed with serif terminals, the top serif is drawn larger than the bottom. It should be noted that in many typestyles, including Raleigh and Bernhard Modern, the C has no bottom serif. Generally, the weight stress of the main curve falls a little below the midpoint of the bowl.

C Baskerville
Bernhard Modern C

In sans serif typefaces there is a subtle thinning of the stroke weight at the top and bottom of the character, usually with the top being slightly thinner than the bottom.

ITC Machine

Monotype Onyx

Copperplate
Gothic 31

Cosmos
Extra Bold

Barmeno
Bold

News Gothic Oblique

Stencil

THE LETTER

Caslon Open Face

Letraset Heliotype

Lithos

Letraset Dolmen

Much of our alphabet was built on a series of misunderstandings. In some ways it is the result of a series of blind adoptions rather than the carefully planned parenthood one might expect. When the Phoenicians cultivated the seeds of our alphabet from Egyptian hieratic script, they were not necessarily aware of the background and meaning of its characters. They simply started using them, which is roughly akin to assembling a ten-speed bicycle without reading the instructions. Likewise, when the Greeks adopted many of the Phoenician letterforms, they did so without a full understanding of their meaning or function. At that point, our ten-speed bicycle was then modified with some additional parts, old as well as new.

The problem was that many early written languages developed by means of *acrophony,* or using what was originally a logogram, which is a graphic symbol that represents an entire word, as a phonetic symbol for the initial sound of the word that it represents. The transfer of meaning from one language to another could be made very smoothly if speakers of different languages used words starting with the same sound to identify the same things. Unfortunately, though perhaps not unexpectedly, this was not always the case in the ancient world.

Therefore, when the Egyptians used the symbol or graphic equivalent of a hand, or *deret,* to indicate the sound value of *d,* it served its purpose adequately. When the Phoenicians adopted much of the Egyptian hieratic system of writing, however, they didn't know what meanings had previously been assigned to each of the symbols. For example, it has been speculated that the Phoenicians interpreted the Egyptian hieratic form used to indicate the *d* sound as a drawing of a door to a tent, or part of a wooden door. As a result, they called the character *daleth*—their word for "door." The daleth eventually evolved into something that looks like the percussion instrument known as a triangle.

The Greeks had apparently adopted the acrophonic principle from the Phoenicians. However, because they had no understanding of the Phoenician name for each of the letterforms, they let that name (or something close to it) represent their version of it. Thus, the Phoenician *aleph* became *alpha, beth* became *beta,* and *daleth* evolved into *delta.* (In contrast to the Phoenician letter names, most of the names that the Greeks used were simply transliterations of the Phoenician that didn't refer to anything other than the letterforms.) Over time, the Phoenicians' somewhat haphazard rendering of a door developed into the orderly, and at times symmetrical, triangle-shaped Greek letter familiar to college fraternal societies. Sometime later in its evolution, the triangular D was tipped to balance on one of its points. Later a modified (rounded) version of the basic shape was also used from time to time.

The Etruscans, from whom the Romans borrowed their alphabet, adopted this softened version of the letter when they wrote. Sometimes it looked remarkably like the capital D we use today, and at others it looked more like a P. The Romans then further refined the D into the balanced and deceptively simple shape with which we are now so familiar.

While those of us not in college normally have little use for the Greek delta, the legacy of this character lives on in words like "delta wing," "deltoid," and "river delta." In addition, one almost extinct group of Americans still makes active use of the delta symbol in written communication: Hoboes use it to indicate "a soft touch." When drawn on or near a house and in conjunction with two or three smaller ones, the delta advises other hoboes that a "pitiful story" succeeded in obtaining food—or a night's shelter.

The D is one of those letters that looks like it ought to be constructed out of a simple straight line and the arc of a circle. It can't be. (Or rather, the good ones aren't.) The straight vertical stroke of the D can be just that, but in many alphabet designs there is a delicate swelling at each stroke end. If this subtle trait is a part of the character, then an even subtler one is also necessary: The bottom swelling must be just slightly heavier than the top.

The curved part of the letter is also more complex than it seems. Starting at the top of the vertical stroke, it turns almost imperceptibly upward as it decreases slightly in width. Its swell at its widest point is always just a little heavier than the straight stroke, and this weight is carried through the mathematical center of the letter (to about four o'clock). The curve then joins with a strong yet graceful connection at the bottom of the vertical. Sometimes there is even a gradual movement upward just before it meets the straight stroke. In some designs, the curve begins virtually at the top of the straight stroke. At the bottom, however, there should be a short, flat "passage" between the bowl and the main vertical to ensure stability on the baseline.

Some type designs carry the heaviest bowl weight above the optical midpoint. Hiroshige is an exaggerated example, while ITC Berkeley Oldstyle is a more subtle one.

D Hiroshige Book
ITC Berkeley Oldstyle D

If serifs are part of the design, the one at the baseline is usually just a little larger than the one at the top. This also gives the character strong footing. In some typestyles the lower serif is raised slightly above the baseline, a rare approach that is usually employed to prevent visual distortion.

All this complicated construction serves to make the finished letter appear optically correct and, for serif designs, so that it appears to have been drawn with a flat-tipped brush. Ds are difficult to construct but easy to draw.

Triplex Condensed
Serif Black

Gill Sans

Letraset
Follies

ITC Galliard

Letraset
Mekanik

Kaufmann Bold

Duc De Berry

25

THE LETTER

E

Have you ever noticed that the Tuesday morning meeting that is supposed to answer everybody's questions rarely does? This is not a new phenomenon; it has long been prevalent in business. Now, unfortunately, it is beginning to creep into other aspects of our lives. There are fewer and less satisfactory answers to questions like: "Why won't my car start?", "Why isn't my report worth an A?", or "What do you mean you can't balance the checkbook?"

So it is with the origins of our alphabet. The seemingly simple question is "What's the origin of the E?" Sorry, but there's no simple answer.

Several experts believe that our E, or at least some of the sounds it represents, was once signified by the Egyptian hieroglyph for "house." Others contend that it evolved from the sign that depicted a window. And still others attribute the E's ancestry to the Egyptian symbol for "courtyard." To further complicate matters, our E, one of the most commonly used vowels, actually started life as a consonant.

The Phoenician alphabet had twenty-two consonant sounds (vowels were relatively unimportant), each of which had a name and a symbol to represent it in writing. One of these twenty-two sound symbols was the precursor to our E.

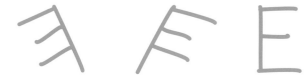

The Phoenician letter called *hé*, which roughly represented our *h* sound, was probably the great-great-grandparent of the fifth letter of the Latin alphabet. When the Greeks adopted the Phoenician alphabet, they had difficulty pronouncing about half of the character's names, so they modified the more troublesome characters to synchronize them with their own language. Some they altered only slightly, others drastically, and others they dropped altogether.

The Phoenician hé was one of the problem characters. The Greeks could not pronounce the first sound of the letter name. Being a pragmatic peo-

ple living in less complicated times, their solution to the problem was simply to drop the part of the name that was causing the difficulty. As a result, the Phoenician hé became just *e*—and thus our most useful vowel was born.

Over time, the Greeks gradually simplified the design of the hé, flopping it so that its arms were pointed to the right. The end result looked remarkably like the E found in typefaces like Helvetica or ITC Avant Garde Gothic. The final version was given the name *epsilon* and represented a short *e* sound.

Avenir 45 Book

Senator Demi

Adobe Garamond Semibold
Italic Alternate

ITC Galliard Bold Italic

Futura Extra Bold

26

The E is generally drawn as a somewhat narrow letter. Its width, excluding serifs, is approximately half its height. The central arm is almost always drawn above the true center of the character, which gives the letter both balance and proportion. In some mannered designs, especially those with art nouveau overtones, the central arm is placed quite high. The central arm is also usually the shortest of the three horizontals. The differences in length should be subtle, but the central arm should be slightly shorter than the top arm, and the top arm not quite as long as the baseline stroke. These variations in arm length are also found in sans serif designs, although they may not be immediately apparent.

In some designs, like Kennerly, the central arm has a serif, while in others, like Palatino, it has none. In faces like ITC Bookman and Caslon, the serifs at the ends of the arms are very pronounced. When established in the E, this treatment is then usually carried through the typeface, reappearing in the F, the L, and the T, and to some degree in the Z. In some roman designs,

the serif on the bottom arm ends in a virtual flourish rather than a constructed serif. This exaggeration is further emphasized in faces like Goudy Old Style, where the whole bottom stroke curves upward.

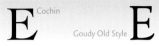

Because the E is one of the two letters (the other is Z) that touch the top and bottom lines with horizontal strokes, in handlettered versions some adjustments may be necessary to ensure that the height of the character is not optically disproportionate with surrounding letters.

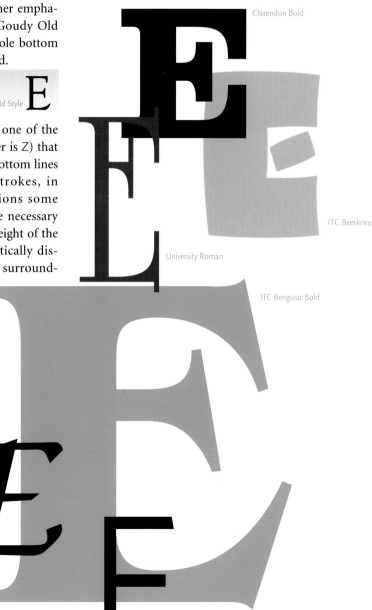

Clarendon Bold

ITC Beesknees

University Roman

ITC Benguiat Bold

Albertus

ITC Zapf Chancery

ITC Kabel Book

THE LETTER

Our present-day F had a difficult childhood. Before maturing as the solid citizen of the Latin alphabet, it held many jobs and appeared in public in a variety of costumes. The F even "dropped out" for an extended period to hold a position in a counterculture alphabet.

Adobe Garamond Italic

Bembo

Formata

In its earliest years, our F was disguised as a snake—actually, a horned snake, or something that vaguely resembled a sea-serpent. This was around 3000 B.C., when it served as the Egyptian hieroglyph *cerastes*.

Not entirely happy with this image, the F began to change its character through the process of simplification. Eventually it lost all resemblance to a creature of any kind, and was little more than a squiggle with a topknot. Still dissatisfied, the F continued to simplify itself. In fact, by the time it emerged as an Egyptian hieratic form it was nothing more than an almost vertical stroke capped by a small crossbar. With only a slight stretch of the imagination, it could be said to look like a nail.

Which may be why the Phoenicians called it *waw*, which means "nail" or "hook," when they adapted the symbol into their alphabet. In its new job as a waw, the character represented a semiconsonant sound, roughly pronounced as the *w* in the word "know." The trouble was that, at various times, the waw also represented the *v* sound, and sometimes even the *u* sound.

When the Greeks assimilated much of the Phoenician alphabet, they handled the waw in a typically Greek-and-very logical-manner. They split it into two characters: one representing the *w*, and the other became the forerunner of our *v*. The *w* sound became the Greek *digamma*, or double gamma, which was constructed by placing one gamma on top of another.

But the F was still a problem child. Because ancient Greece was made up of many autonomous city-states that used the same basic alphabet to construct an almost equal number of dialects, the F (and several other letters, for that matter) was used for a variety of purposes. In 400 B.C. one alphabet was officially adopted in Athens and was subsequently used throughout Greece. The digamma was not a member of the surviving alphabet.

Luckily, the digamma was able to find useful work in the Etruscan language, where it provided yeoman service until the Romans adopted it as a symbol for the softened *v*, or "double v" sound. Even today the German language (an important source for English) still expresses the *v* as an *f* sound, in such words as *vater* ("father" in English; pronounced FAH-ter). Finally, the sensuous horned snake found a permanent home as the very geometric sixth letter of the Latin alphabet.

Cooper Black

The F is about half the width of the M, and its center arm, which is normally just slightly shorter than the top one, is usually positioned a little above the mathematical center of the character's height.

While it is true that the design of the F is very similar to that of the E, one should not presume the F to be an E with its bottom stroke missing. In spite of its unmistakable resemblance to the E, the F presents a problem to type designers that is not present in the E: It is asymmetrical—top-heavy, in fact. As a result, designers very often incorporate a few subtle yet essential characteristics into the F that distinguish it from its three-armed alphabetical precedent. For instance,

sometimes the center arm of the F is slightly shorter or placed a little lower than its counterpart in the E. Occa-

ITC Stone Sans

sionally in serif designs the base of the vertical stroke exhibits a slight flair, where the same feature in the E might only end in a taper.

Lunatix Light

Ponderosa

Monotype Onyx Italic

Barmeno Extra Bold

Blackoak

Adobe Caslon Swash Italic

ITC Anna

Bovine Poster

As letters go, the G is a comparatively modern invention. It wasn't until about the third century A.D. that it experienced widespread use. Until that time the letter C did double duty, performing in its own phonetic roles as well as those of the G.

The Phoenicians and the other Semitic peoples of Syria used a simple graphic form that looked roughly like an upside-down V to represent the hard *g* sound. They called it *gimel,* which was Phoenician for "camel," possibly because the upside-down V looked like the hump of a camel. Maybe.

The Greeks borrowed the basic Phoenician form and changed its name to *gamma.* They also made some pretty dramatic changes to the way the letter looked. They twisted it, turned it, reversed it, and generally had a field day with the basic character shape. At any given time in ancient Greek history, the gamma could have looked like a one-sided arrow pointing up, an upside-down L, or a crescent moon. Throughout this period, however, the gamma remained constant in that the Greeks used it to represent the same hard *g* sound for which the Phoenicians had devised the gimel. The gamma was adopted first by the Etruscans, and then by the Romans, for whom it represented both the hard *c* and *g* sounds (as in "cat" and "gate"). The Romans also defined the full-bodied, round shape of the letter, which at that point looked like our C.

Ultimately the Romans differentiated the two sounds graphically. The basic shape, which looked like our C, was used to represent the palatized sounds of *s* and *c* (as in "sit" or "city"), and a little bar was added to its spur to create the letter G, which denoted the guttural stop *g* (as in "got").

For the most part, the evolution of each letter of our alphabet cannot be broken down into discrete developmental stages to produce clear "snapshots" of design and shape, nor can specific dates of introduction or modification be determined. Characters developed gradually, and over long periods of time. The G is an exception—it actually has an official date of introduction. The history of our G begins with the reformed Latin alphabet, into which it was formally introduced by Appius Claudius Censor in 312 B.C. The G was created for two purposes: to eliminate the confusion caused by using one letter to represent two sounds, and to replace the letter Z, which until that time had been the seventh letter of the alphabet. The Z, which was considered superfluous to the Latin language, was moved to the end of the line, and the new letter, G, was put in its place.

Modula

Bellevue

AG Old Face Shaded

Bank Gothic Medium

Baskerville

Bodoni Poster
Compressed

The G, like the C, is approximately as wide as it is high. And like the C, the top of the letter is flattened slightly and the top terminal may be either sheared or given a beaked serif. Also like the C, the thickest part of the G's bowl usually falls below the true center of the letter. But the G is not simply a C with a vertical stroke and a crossbar.

C Century Old Style G

Because the G is generally a heavier-looking character, its top serif can be slightly smaller than the C's. In addition, just before the curve at the base of the letter connects with what is usually a rather heavy vertical stroke, it straightens somewhat and subtly increases in width in order to provide adequate optical support. Sometimes, in an added attempt to counteract the visual stress of the joining of these two strokes, a small protuberance, or spur, extends from the right side of the vertical at the point nearest the baseline. Trump Mediaeval has such a spur.

Regardless of its weight, the vertical stroke can appear in a variety of lengths. In Goudy Old Style, for example, it is quite long—almost making the character look like an O—while in most Bodoni designs it is very short. These two typefaces tend to mark the extremes of this element's length, as anything much longer or shorter can detract from the legibility of the character and can potentially cause the reader to confuse it with the C or the O from the same typeface.

G Goudy Old Style G Bauer Bodoni

In serif designs the vertical stroke usually has a top serif, a treatment that generally reflects its appearance on the bottom serifs of the design's other characters. In sans serif designs the vertical might stand on its own, as can be seen in Optima, or has a short horizontal connecting stroke that extends into the counter, as it does in Univers.

G Optima G Univers 45 Light

In the second model, another stroke, perpendicular to the first, might continue down toward the baseline to create a spur of sorts, as in Helvetica.

G Helvetica Light G Futura Book

In geometric sans serif designs like Futura and ITC Avant Garde Gothic, the curve of the letter continues its path very much like the C, and attaches to a horizontal, rather than a vertical, stroke.

Letraset Pleasure Bold Shaded

Clarendon

Futura Bold

Park Avenue

Arcadia

Standing firm on its two-footed foundation, and nearly always predictable in design and use, the H is a model of stability. For example, it has consistently held the same position as the eighth letter in the Semitic, Greek, Etruscan, and Latin alphabets. It can be said that of all the letters, the H is, well, the most boring. It is only in the hands of type designers like Ed Benguiat, or in words like "heliotrope," that the H looks the least bit exotic.

Many historians believe that our eighth letter started out as the Egyptian hieroglyph for a sieve. Providing an almost tedious steadiness of personality, it represented the same guttural, rough breathing sound (sort of like clearing your throat) used by the Sumerians over a thousand years later. The Semi-

tes called their eighth character *kheth*, which means "fence," and represented it by a drawing of something that could be imagined to look like a fence, or at least part of one.

Somewhere around 900 B.C. the Greeks borrowed the sign. They dropped the top and bottom horizontal bars, and since they couldn't pronounce (and

had no linguistic use for) the sound signified by the kheth, they simply abandoned that part of it and called the letter *eta*. Although the eta was first used to denote a guttural, rough breathing sound, it gradually came to represent the sound of a long *e,* to distinguish it from the short *e* sound of epsilon.

When the Etruscans and Romans adopted the eta into their alphabets, each handled it somewhat differently. The Etruscans put back the top and bottom crossbars that the Greeks had removed, while the Romans continued to leave them off.

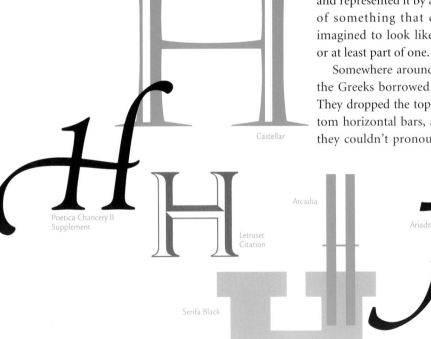

Castellar

Poetica Chancery II
Supplement

Letraset
Citation

Arcadia

Serifa Black

Ariadne

ITC Machine

For type designers the H poses the problem of how to connect, rather than push apart, two strong verticals. Despite the fact that it tends to look square, it is a relatively narrow letter whose width is typically about three-fourths of its height.

As in the B, the E, and the R, the H's horizontal stroke usually sits slightly above its mathematical center. Sometimes it can be placed quite high or low, resulting in a mannered, albeit less boring, look.

ITC Anna Baskerville ITC Benguiat

The severity and simplicity of the H's design inspires some type designers to add ornamentation to the crossbar. Generally this strategy is ineffective, and virtually impossible to successfully implement in a type design intended for text composition.

The H is a very important letter. Along with the capital O and lowercase n and o, it is one of the first letters of an alphabet on which traditional type designers will begin their work. The H, in addition to these other characters, helps lay the foundations for stroke weight, proportion, and spacing relationships that are applied to the rest of the alphabet.

Letraset Dolmen

Bank Gothic Medium

ITC Bookman Demi

Variex Light

Charlemagne

Copperplate Gothic 33

Letraset La Bamba

The I and J are not only immediately adjacent in alphabetical sequence and look a lot alike, but to a great extent they also share the same history.

The original Phoenician symbol evolved over time into a zigzag shape, which was eventually adopted by the Greeks. The Greeks tended to simplify

Like the G and the F, the I took some time to make up its mind deciding which sound to represent. The Phoenicians used it as a semiconsonant, as

Egyptian Sumerian Phoenician Greek 16th Century

The Phoenician ancestor to our present-day I was a character called *yodh*, which meant "a hand bent at the wrist." With a real stretch of the modern imagination, this sign can be interpreted as a hand. Some say that the yodh can be traced back even further, to the ancient Egyptian hieroglyph of a leaf, which supposedly later evolved into a hieratic symbol that also resembled a hand. This Egyptian part of the I's story is most probably a typographic fairy tale, for two compelling reasons: first, because there are at least as many experts who disagree with the theory as there are those who agree; and second, because the analogous Sumerian and Assyrian-Babylonian symbols that predate the Phoenician yodh and were, to some degree, influenced by Egyptian culture bear no resemblance to a hand.

the symbols that they adopted from the Phoenicians, and the yodh was no exception. In their hands the zigzag became a simple vertical line. They also changed the name of the letter to *iota*. Yodh was the smallest letter of the Phoenician alphabet, and perhaps cognate with this fact is that the word "iota" means "immeasurably small," as in, "There isn't one iota of truth in what you just said." Also related is "jot," which means a small note or mark.

the *y* in "toy." When it was adopted by the Greeks around 900 B.C., they used it to represent the vowel sound of long *e*. Then it was used in early Latin to represent both the vowel *i* and the consonant *y*. Eventually somebody got tired of using the same letter to represent two distinct sounds, and tried to differentiate them by lengthening the I slightly to represent the *y* sound. When a sixteenth-century calligrapher decided that this refinement was too subtle, he added a hook to the bottom of the stroke, the distinction between the I and the J was finally established.

Thus the ninth, simplest, and smallest letter of our alphabet also has one of the more complicated histories—one that is made even more intricate because it is shared with the tenth letter of our alphabet.

Berthold Script

ITC Anna

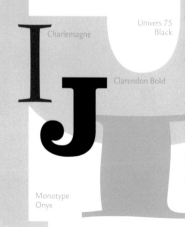

Charlemagne

Univers 75 Black

Clarendon Bold

Monotype Onyx

ITC Ozwald

The I isn't difficult to design, and has no optical considerations or caveats to contend with. A straight vertical line the width of the particular typeface's standard stroke, seasoned with serifs when desired, is pretty much all there is to it.

The hook of the J should either extend just slightly below the baseline (for optical reasons) or very far below the line.

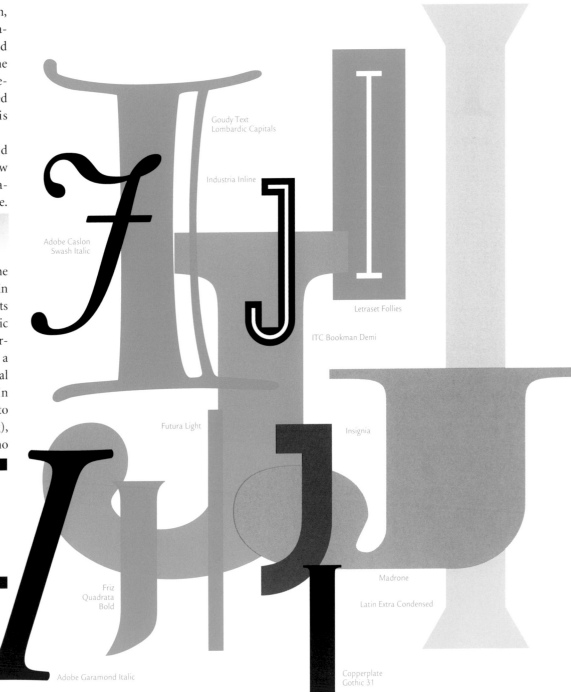

The latter treatment allows the character more even spacing in relation to others and imparts a little more drama to the basic shape. The end of the hook terminates in either a serif or a ball terminal, a typographical feature exclusive to the J: In the classical Latin alphabet (to which the J does not belong), the ball terminal appears on no other capital letter.

Caslon 3

Caslon 540

Goudy Text
Lombardic Capitals

Industria Inline

Adobe Caslon
Swash Italic

Letraset Follies

ITC Bookman Demi

Futura Light

Insignia

ITC Lubalin Graph Book

Friz
Quadrata
Bold

Madrone

Latin Extra Condensed

Broadway

Adobe Garamond Italic

Copperplate
Gothic 31

THE LETTER

K

Some letters seem to be slaves to fashion, continually changing their images to suit new writing utensils or languages. The F is a prime example, the typographic equivalent of a clotheshorse, swapping flowered shirts, bell-bottoms, and three-piece suits for paisley ties, splayed collars, and double-breasted jackets. In contrast, the K is a paragon of conservatism, virtually always seen in wing-tip shoes and button-down collars.

The K was the eleventh character in the ancient Semitic alphabet, a position it has retained to this day in our current character set. It has also probably varied less in form than any other character. The forerunner of our K, the Semitic sign *kaph* was a three-stroked character that represented the palm of an outstretched hand. The Semitic tribes of 1000 B.C. practiced palmistry, so it is not surprising that they chose such a symbol to represent one of their phonetic sounds.

Several versions of the kaph were used by the Semites, particularly by the Phoenicians, but all were composed of three strokes drawn in a similar fash-

ion. The first version was a simplified drawing of a right hand, the next looked something like our Y with a short middle stroke between the two longer diagonals, and the last, whose form was reduced even further, was turned on its axis so that its two diagonals pointed left, much like a backward version of our K. Although the character was modified and reoriented in each of these evolutionary steps, its basic form remained very much the same.

The Greeks adopted the latest version of the kaph and introduced symmetry into its design, eventually turning it around so that the diagonals

faced right. The Greeks even kept the basic name of the letter, changing it (barely) to *kappa*. In the Greek language, two signs were used to represent the *k* sound: the kappa and the *koppa* (the predecessor of our Q). The Etruscans, however, had three signs for the same sound: the C, which was employed before the *e* and the *i* sounds; the K, which was used before an *a;* and the Q, which always preceded a *u.* The early Romans adopted all three, but in time dropped the K, using it only in adopted Greek words, or in those of an official nature. The latter use was probably the reason the K appeared in the Roman monumental inscriptions, which set the standard for our current design.

Bellevue

Manhattan

Futura Extra Bold

Adobe Caslon
Swash Italic

Cloister

Formata
Condensed Light

The K is normally somewhat narrower than it is high, usually a little over half as wide. While the K is a relatively straightforward letter to render by hand and requires no optical "tricks," type designers must give some consideration as to how and where its two diagonals join, ensuring that the junction of the three strokes does not create an optical dark spot. Generally the diagonals meet at the main vertical's midpoint, or slightly higher. In stonecutting the juncture of these two strokes remains simple, and occurs at the optical midpoint of the vertical. The K in Univers is an excellent example of this approach as applied to modern type design. In designs where the letter is obviously constructed (as opposed to being calligraphic), the thin upward stroke aligns well below the true center of the vertical, and the heavier downstroke originates above it, from a point on the lighter diagonal. Sometimes the lower diagonal connects with the upper considerably above the midpoint, giving the letter a high-waisted appearance. ITC Benguiat is a prime example of this form of K. To provide the character with a firm base on which to stand, the lower diagonal should extend slightly beyond the upper.

There are a few characters in our alphabet that give the type designer an opportunity to add a flourish or touch of personality to the basic form. The Q and the & are ideal for this, as is the K, if only to a slightly lesser degree. Often the K's lower diagonal is suffused with a little more energy than is generally apparent in similar strokes in other characters.

K Univers

ITC Benguiat Book K

Optima

ITC Berkeley Oldstyle Book

ITC Korinna Bold

ITC Mona Lisa Solid

Berthold City

Berthold Script

ITC Serif Gothic

Senator Demi

ITC Tiffany

THE LETTER

L

The ancestor of our L was instrumental in unlocking the secrets of ancient Egyptian culture. The *l* sound was one of those represented in the names of Ptolemy and Cleopatra on the Rosetta Stone.

When the stone was discovered in 1799, it sparked considerable interest among scholars as well as the general public. Because it apparently bore the same message carved in Egyptian hieroglyphics, Egyptian demotic script, and Greek, it was believed that the four-foot slab of black basalt could help reveal the mysteries of Egyptian hieroglyphics. Scholars correctly deduced that each cartouche, which is an inscription enclosed in an oval (a symbol of royalty), represented the name of a ruler. The scholars presumed, also correctly, that the ruler whose name appeared most frequently was Ptolemy, and that the name that occurred next most often was Cleopatra's. The symbols shared by both names—those denoting the sound values of *p, t, o, l,* and *e* —were instrumental in deciphering the hieroglyphics. The Egyptian glyph representing the *l* sound was first depicted by the image of a lion. Over

centuries this evolved into a much simpler hieratic character, which served as the basis of the letter we know today.

When the Phoenicians developed their alphabet around 1000 B.C., the *l* sound was signified by a number of simpler versions of the hieratic character, some rounded and some more angular. From this point on, the simple and straightforward L became a rather complicated character, taking on a variety of forms (sometimes simultaneously) in just about every alphabet in which the *l* sound was represented.

The Phoenicians called their version of the letter *lamedh,* which meant "goad" or "lash." Through a stretch of the modern imagination, a whip or lash can be seen in the basic shape of the lamedh, which is made

Cochin Bold

up of two strokes, one of which probably represented the handle of the whip, while the other represented the thong.

Not to be outdone by any of their literate neighbors, the Greeks had four versions of the L. As they had done with so many other letters, they had borrowed the basic shape of the Phoenician character, making some slight modifications to its design and name. They established the angular quality of the letter, and changed its name to *lambda.*

The Greek rendition of the L that the Romans initially adopted looked more like an arrow pointing southwest than the right-angled character we currently use. Over time, the letter evolved into the precisely rendered horizontal- and vertical-stroked character that appears on Trajan's column— and the one we use today.

ITC Avant Garde Gothic Book

Charlemagne

Poetica Chancery II Supplement

Broadway Engraved

Berling

The L is a narrow letter, essentially an E with the top and center arms removed. The horizontal stroke is approximately half the cap height, but in some designs it is smaller. In most roman designs the end of the horizontal stroke terminates in a serif, generally reflecting a consistent treatment of similar strokes throughout the character set. In some serif typefaces,

L ITC Tiffany

Goudy Old Style L

however, like Goudy Old Style and Poliphilus, the horizontal ends in what looks like a tapered brush stroke. In contrast to constructed typeface designs, the handlettered L's horizontal stroke can be either lengthened or shortened, depending on the letter that follows it. A few typefaces provide an alternate L with a horizontal stroke that swashes under adjacent characters.

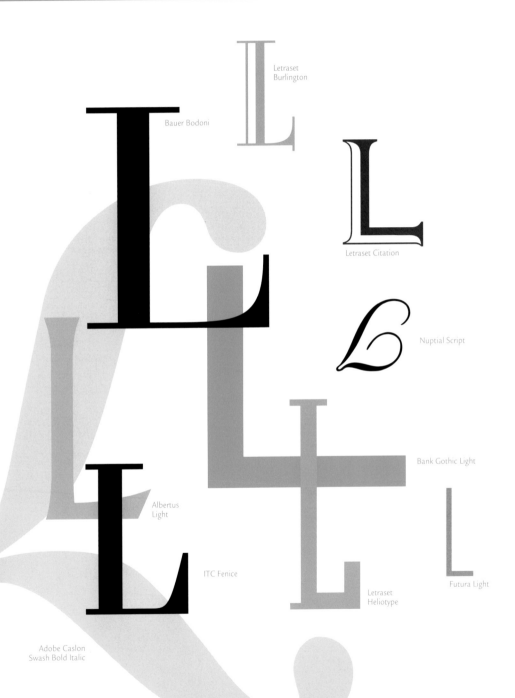

Letraset
Burlington

Bauer Bodoni

Letraset Citation

Nuptial Script

Bank Gothic Light

Albertus
Light

ITC Fenice

Letraset
Heliotype

Futura Light

Serifa Black

Adobe Caslon
Swash Bold Italic

Arcadia

M

Historians tell us that our current M began as the Egyptian hieroglyph that depicted an owl. From this simple line drawing it was further distilled over thousands of years into the hieratic character representing the *m* sound. By that time the great-grandparent of our M looked a little like a handwritten m balanced on the tip of one stroke.

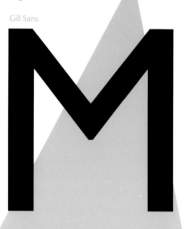

The Phoenicians called their *m*-letter *mem*. It's easy to see that this character is based on the Egyptian hieratic symbol, and that it is clearly the forerunner of the thirteenth letter of our alphabet. The Phoenician letter looked almost like our three-humped lowercase m with a tail added at the end.

The Greek *mu* evolved from the Phoenician mem. During the adoption process, the Greeks typically converted the mem's soft round shapes into angular ones. The Greek mu was acquired first by the Etruscans, and then the Romans, neither of whom changed its shape or proportions. The Romans also pressed the M and six other letters—I, V, X, L, C, and D—into double duty as their numerals, granting the M the honor of representing the highest value, 1,000.

Omnia

ITC Mona
Lisa Solid

Arnold Bocklin

Gill Sans

Berthold Script

Geometric 415
Black

Variex Bold

The M is one of the widest letters, its width being almost equal to its height. Although the W is almost always wider, the M traditionally determines the width, or "set," of a typeface in metal type. It was generally assumed that the M required a perfectly square platform (the flat surface below the raised letter on a piece of metal type).

The M can also be thought of as a V with supporting legs. The angle of the V can vary, and the supporting limbs can either be vertical or splayed a few degrees, as can be seen in Plantin and Trump Mediaeval.

Because of its many strokes, the M is one of the most difficult characters to design. Condensing an M is an especially difficult task, especially in serif designs. The second and third strokes meet somewhere in the space between the first and last strokes. Most of the time the point where they join, which is called the vertex, occurs at the actual center of the space, but a type designer may make subtle adjustments so that the vertex occurs instead at the optical center. The M's vertex rarely descends below the baseline, as it does in the N, the V, and the

W. Many times, in fact, the M's vertex sits some distance above the baseline.

A key to designing the M is to make the upright strokes appear to firmly support the others. In the Ms of serif designs, the top serifs usually point outward.

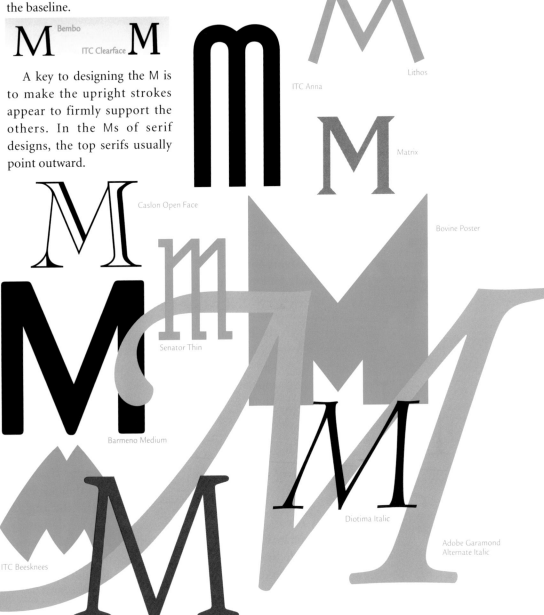

ITC Anna

Lithos

Matrix

Bovine Poster

Bembo

ITC Clearface

Caslon Open Face

Senator Thin

Barmeno Medium

ITC Beesknees

Diotima Italic

Adobe Garamond
Alternate Italic

Plantin

ITC Weidemann Book

41

O

Some scholars believe that our current O evolved from the Phoenician *ayin*, a symbol used over two thousand years ago. Others contend that a 5000-year-old Egyptian hieroglyph depicting a knotted cord was the first use of what was to become the fifteenth letter of our alphabet. Rudyard Kipling, however, dates the conception of the O even farther back in history. In his *Just So Stories*, he tells how a Neolithic tribesman and his precocious daughter invented the alphabet.

According to Kipling, the O was the third letter of the alphabet to be devised by those designers of the distant past. They had just finished the A and the Y (the head and tail, respectively, of a carp) when the girl asked her father to make another sound that she could perhaps translate into a picture.

"Oh!" cried out the father.

"That's quite easy," said the daughter. "You make your mouth all around like an egg or a stone. So an egg or a stone will do for that."

"You can't always find eggs or stones," said the father. "We'll have to scratch a round something like one," and he drew the first O.

Actually, the O probably did start out as a drawing of something, but not a stone, an egg, nor even a knotted cord. The true ancestor of our O was probably the symbol for an eye, complete with a center dot for the pupil. The ayin (pronounced EYE-in, which meant "eye") appeared among the Phoenician and other Semitic alphabets around 1000 B.C.

When the Greeks were exposed to the ayin, they adapted it to their communication system and assigned it to represent the short *o* sound. They also changed the name of the letter to *omicron*. The *omega* is another Greek O-letter, which they used to represent the long *o* sound.

While the Phoenicians and the Greeks drew the letter as a true (or nearly perfect) circle, the Romans compressed its shape slightly to make it consistent with their other monumental capitals.

ITC Avant Garde Gothic Book

Bauer Bodoni

Bodega Sans

Futura Extra Bold

Caslon Open Face

ITC Ozwald

The stroke weight of all Os, even those of the sans serif variety, thins slightly at the top and bottom of the character. This is almost imperceptible in typefaces like ITC Avant Garde Gothic, while in designs like Bodoni or ITC Fenice it is quite dramatic. In most type designs, the part of the stroke at the top of the O is also slightly thinner than the part at the bottom. This is done to give the letter an optically strong foundation.

The stroke weight of the Roman monumental O is heaviest at approximately two and eight o'clock. This tilted axis reflects that the letters were first drawn with a flat-nibbed pen or flat brush, the swelling stroke of the broad brush creating gradated thick and thin curves as it traced the character.

Over time, as type designers reinterpreted the O's basic shape, its thickest part shifted to a more horizontal position.

The letter O can be perfectly round, as found in Futura and Schneidler Old Style; condensed, like those in Erbar and Torino; egg-shaped, like the O in Revue; or even slightly square, like the Os found in Melior and Eurostile.

Futura Erbar Revue Eurostile

The O is one of the "control characters" in a typeface, through which the designer establishes many of the design parameters for the rest of the face. It sets the standard for the round capitals' stroke weight, top and bottom hairline weights, and spacing and width proportions, as well as the width of the bowl stroke relative to vertical strokes.

One of the fundamental rules of handlettering and typeface design is that round strokes are always heavier than straight verticals. The degree to which this rule is carried out depends on the individual typeface and the sensibilities of the designer. It should not be readily apparent, however, that curved strokes are heavier than straight ones.

THE LETTER

P

Jargon is usually an outgrowth of technology. Sometimes, if the technology is around long enough, its jargon becomes part of our daily language. For instance, the term "zipper" was first used by B.F. Goodrich as the brand name for overshoes that featured a new fastener. "Laser" is an acronym for *Light Amplification by Stimulated Emission of Radiation*. And the word "jeans," everyone's favorite apparel, is short for "Gene fustian," the heavy cotton cloth first used to make them.

Perhaps jargon was also one reason the Phoenicians developed their own alphabet. They lived in a more complicated world than the Egyptians who preceded them, a world filled with more technology—and perhaps more jargon. The words of the Phoenicians would then be difficult to communicate in the manner of the Egyptians. For example, in ancient Egypt a warrior could be represented by the pictures of a man and a weapon, but how would a merchant, money lender, or trader be represented? To cope with this problem, the Phoenicians developed a modified picture alphabet around 1300 B.C. In this new alphabet, pictures were used not to represent the things they depicted, but for a sound in the name of the thing.

The letter P is a perfect example. In Egyptian hieroglyphics, the drawing of a mouth would have meant just that, a mouth, or perhaps someone talking. In the Phoenician alphabet the symbol of a mouth represented the initial sound of its Phoenician name, *pe,* which actually had two forms: a rounded shape that looked a little like an upside-down J, and a more angular form that was derived from a Sumerian character.

The Greeks borrowed the sign from the Phoenicians, but at that point the details of the story get a little confusing.

What looks like our P in the Greek alphabet actually represented the *r* sound, while the *p* sound was signified by a more geometric asymmetrical shape. This character was then further modified and, as the Greeks were wont to do, made symmetrical. The final outcome was the sign they called *pi.*

The Romans inherited their more rounded P, which looked similar to the earlier Phoenician sign, from the Etruscans. In time the Romans reversed the direction of the character and in the process completed, or nearly completed, the bowl to make the monumental P that serves as the prototype of all forms of our letter.

Although it is not used nearly as much as the E, the most frequently used letter in our alphabet, the P is nevertheless very important to the English language. Nearly 10 percent of all English words begin with the letter P, establishing its position as third (following S and C) for frequency of word beginnings.

Futura Light

Diotima Italic

Adobe Garamond
Alternate Italic

ITC Fenice

Bodega
Sans

Trajan

The P is a narrow letter, superficially resembling a B or an R. In spite of this, it is not just an unfinished version of either of these characters. The bowl of the P should swing lower, and in many designs begins to rise a little as it nears the main stroke. In the classic

Roman version the bowl of the P isn't quite closed, and the stroke that defines it ends in a point just before reaching the stem. In sans serif designs the top and bottom of the bowl generally join the vertical at right angles.

In some alphabets, like Bodoni and ITC Century, the lower portion of the bowl connects with the main stem on a strict horizontal axis. In others, such as ITC Korinna, it may advance on a downward curve.

Regardless of how its loop is structured, the P is an elegant character that must be designed carefully to ensure its optical stability and balance.

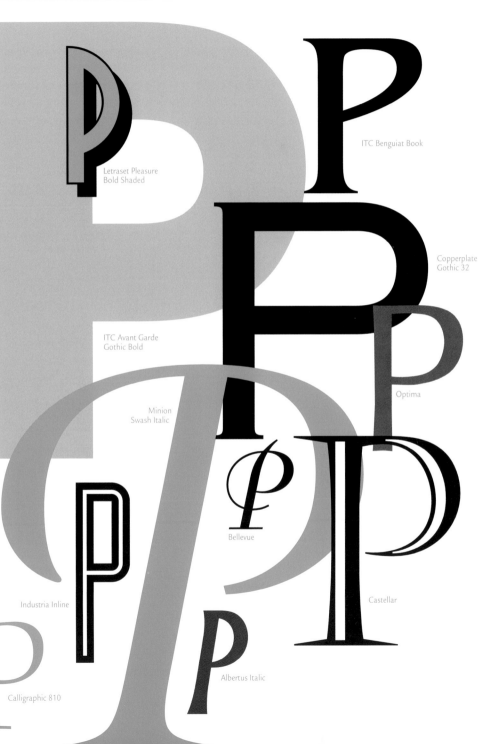

Letraset Pleasure Bold Shaded

ITC Benguiat Book

Copperplate Gothic 32

ITC Avant Garde Gothic Bold

Optima

Minion Swash Italic

Bellevue

Industria Inline

Castellar

ITC Kabel Ultra

Albertus Italic

Calligraphic 810

47

THE LETTER

Type designers walk a pretty narrow path in their work. The letters of our alphabet provide little room for much self-expression when it comes to their defined shapes. The more deeply a designer's "thumb-print" is left on a typeface (in other words, the more distinctive it is), the less likely it is to perform well as a communication tool.

Fortunately for type designers, there are a few exceptions to the rules of type design anonymity. The tails of Rs, italic fs, the descenders of ys, and, of course, ampersands have always provided possibilities for artistic expression to creep into otherwise staid typeface designs. The Q is another character that permits a certain amount of designer personalization, sometimes even to the point of flamboyance. For just about as long as there have been Qs, designers have felt free to have a little fun with the letter's tail. Perhaps there is even some vague correlation between the opportunity to introduce some playfulness into a type design and the fact that the original ancestor of our Q was called qoph, a Phoenician word meaning "monkey."

Most historians believe that the qoph, which was also known as *gogh,* originated in the Phoenician alphabet, with no connection to previous written forms. Historians also believe that the qoph's shape was based on the rear view of a person's head, with its straight tail depicting the neck or throat. This interpretation is feasible, but if you consider that the word "qoph" meant "monkey" then perhaps the round part of the symbol represents another kind of "back-side," and what we refer to today as the "tail" of the Q really started out as just that.

The qoph expressed an emphatic guttural sound not found in English, nor in any other Indo-European language. Although they found the sound it represented difficult to pronounce, the Greeks adopted the qoph, changing its name slightly to *koppa.* In addition, they modified its design somewhat by stopping the tail at the circumference of the circle. Coin-

cidentally, the koppa represented virtually the same sound as the *kappa,* another Greek letter. One had to go, and the koppa was ultimately the loser, perhaps because it had begun to look like yet another Greek letter, the *rho.*

The Etruscans apparently could live with the somewhat redundant nature of the koppa, and continued to use the letter. In fact, they had not only one but two other *k*-sound letters to contend with. The Romans elected to use all three when they adopted much of the Etruscan alphabet. The first Roman Q had the Etruscan ver-

tical tail, but over time it evolved into the graceful, curved shape that blends with the u that usually follows it.

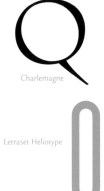

Charlemagne

Letraset Heliotype

Adobe Caslon

Duc De Berry

Avenir 45 Book

Künstler Script Black

Is our Q nothing more than an O with the simple addition of a tail? Yes—and no.

Yes, the basic character is exactly an O, but the design and placement of the tail is no simple matter. If it is too small, the character can be misleading, especially in text copy. However, if the tail is too large or elaborate, it might call undue attention to itself. Placement of the tail is also crucial because it should facilitate the left-to-right flow of the eye in reading, not put a roadblock in the way.

The tail of the Q can be a tiny appendage, like the one found in ITC Weidemann; a free-spirited flourish, like the one found in most Baskerville designs; or anything in between.

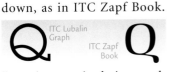

Some Q tails have terminals, presenting the designer with yet another opportunity for freedom of expression. The Q's terminal can curl up, as it does in ITC Lubalin Graph, or turn down, as in ITC Zapf Book.

Sometimes, as in designs such as Cartier or Cochin, the tail is isolated from the rest of the letter. Regardless of the style of tail that is chosen, the designer should avoid positioning its heaviest part at, or close to, the swell of the O's curve. The good news is that it is possible to devise many variations on the Q's tail without interfering with its basic function.

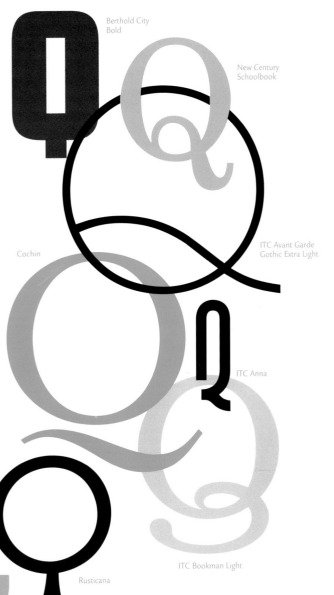

Berthold City Bold

New Century Schoolbook

ITC Avant Garde Gothic Extra Light

Cochin

ITC Anna

ITC Bookman Light

Rusticana

Bodoni Poster Compressed

Blackoak

49

THE LETTER

R

The letter R can be one of the most difficult characters for type designers to create. When designed judiciously, it is rich with subtle details and delicate proportions. The problem is that the R is a more exceptional character than it seems to be at first glance. It is not a P with a tail or a modified B. It is unique among letterforms.

The Egyptian hieroglyph on the Rosetta Stone representing the consonant sound of *r* was known as *ro* and was drawn in the shape of a mouth. In hieratic writing the symbol was modified slightly so that it looked more like a headache capsule.

The Phoenician sign for the *r* sound, the *resh*, bore no resemblance to the Egyptian ro. The word "resh" meant "head" in Phoenician, and was represented in their alphabet by what is assumed to be a very simple rendering of a human profile facing left.

By 900 B.C. the Greeks had adapted the Phoenician letter and renamed it *rho.* They reversed the orientation of the head's profile—a step in the right direction toward creating our R—and converted the curve of the face into an angular form —clearly a step in the wrong direction as far as the R's evolutionary progress was concerned.

The R evolved further in the hands of the Greeks, and ended up looking very much like our P. However, the character that served as the basis for the Roman R was derived from an earlier western Greek letterform to which a short, oblique appendage had been added under the bowl. Seeing a good thing in this differentiation between the R and the P, the Romans lengthened the short stroke into a graceful and delicately curved tail that enhanced the letter as never before.

Futura Light

Medici Script

Senator Ultra

Avenir 45 Book

Calligraphic 810

Gill Sans Bold

50

Frederic Goudy thought the R to be the most interesting of the Trajan letters. The R can certainly test a designer's mettle, but when rendered with skill it can be an extraordinarily beautiful communication tool.

The R can vary in proportion from narrow to medium width. Its bowl is neither the same size nor the same shape as those of the P and the B. The lower contour of the bowl is almost horizontal, while the top contour swells upward. The R's tail can begin at virtually any place along the lower contour of the bowl, and conclude in a variety of ways: in a tapered point, as in ITC Barcelona; curved like the front of a ski, as in Goudy Old Style; or in a discrete serif, like that in Fairfield.

Berling Goudy Old Style Sabon

In many modern typefaces, such as ITC Fenice, the tail of the R ends at the baseline and terminates in a serif.

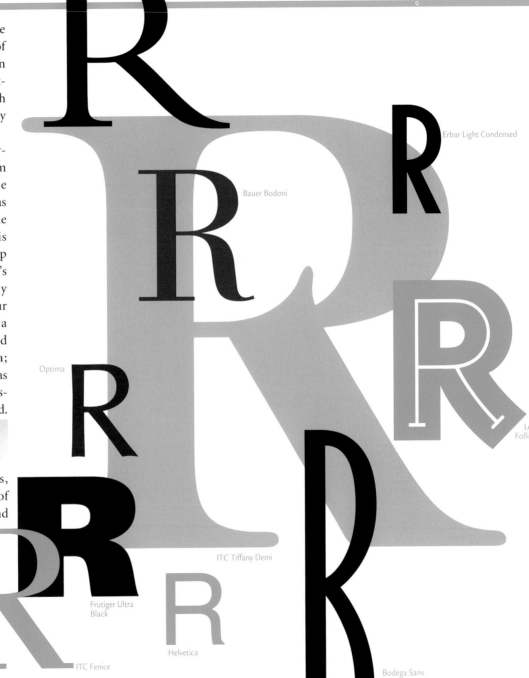

Bembo

Erbar Light Condensed

Bauer Bodoni

Optima

Letraset Follies

ITC Tiffany Demi

Frutiger Ultra Black

Clarendon

ITC Fenice

Helvetica

Bodega Sans

THE LETTER

S

Just about any way you look at it, the S is a complicated letter. Its evolution has had more reverse curves than its shape. Even in its rendering, the S is one of the most complicated characters to draw.

The tangled story of our nineteenth letter probably begins with the early Egyptians and their hieroglyph for the *s* sound. This first ancestor to our S was represented by the drawing of a sword. Later, in the Egyptians' hieratic writing, the sword was simplified and began to look more like a short piece of barbed wire than a weapon of war.

ITC Anna

ITC Bookman Demi

Bellevue

When the Phoenicians built their alphabet on the Egyptian model, they rotated the piece of barbed wire 90° and called it *sameth*, which meant "post." The Greeks, in turn, adopted this letter, but didn't use it to represent the *s* sound, creating a detour on that particular twist in the road of its evolution.

At the same time that the Egyptians were using the symbol of a sword to represent the

s sound, they also used a symbol for a field of land to represent the *sh* sound. In their hieratic writing the symbol was, like other hieroglyphs, simplified in form. But unfortunately for the Egyptian scribes, it became more complex in usage. The reason? The Egyptians allowed as many as nine different versions of the symbol to exist at the same time. There were so many, in fact, that one wonders how they kept track of things.

The Phoenicians dropped most of these Egyptian *sh* sound characters and settled on something that looked like our w to represent the *sh* sound in their language. The Phoenicians called their rendition of the letter *shin* or *sin*, which meant "teeth."

The Greeks borrowed the shin from the Phoenicians, but drew it with three, four, and sometimes even five strokes. In some cases it hardly resembled the original Phoenician symbol, but in each the basic zigzag shape of the letter was main-

tained. In its latest Greek rendition, the character became the *sigma,* which resembles our capital M lying on its side.

The Romans used a form of the sigma that omitted the lower horizontal stroke of the character and made it look a little like a backward Z. Over time, however, the Romans reshaped the sharp angles of the *sigma* into softer, rounded forms, then completed its current graceful shape.

But the story of the S did not end with the ancient Romans; there were still a few twists and turns left to its lineage. As late as the mid-eighteenth century, a lowercase version of the letter, which stood for the long *s* sound and looked remarkably like a lowercase f, was used in English manuscripts. And even today, the German language uses a letter called an *eszett* that resembles a capital B and represents the double lowercase s (a combination of long and short s sounds) in words like *strasse* and *weiss.*

Bodega Serif Medium

The S is a narrow letter, its width being about half its height. Since it is rounded, and would appear short otherwise, it is also designed to slightly overlap the baseline and exceed the normal cap height.

To provide the S with a firm foundation on which to rest, the optical center should be positioned above the true center, making the upper half of the letter appear smaller than the lower. In some typefaces, like Trajanus and Albertus, this arrangement is reversed, making the top counter look bigger than the bottom one. But even

S ITC Benguiat Book
Albertus S

when this is the case, the S should never appear as having been drawn upside down.

The S can vaunt more personality than most other characters. In Windsor it rears back like a snake about to strike; in Nicholas Cochin it has the list of a drunken sailor; and in Letraset's University Roman it has the opulence of old money.

S S S
Windsor Nicholas University
Light Cochin Roman

The S is, in many ways, a complicated letter. Fortunately for readers and type designers, it is also exceptionally beautiful.

Futura Light

ITC Serif Gothic

ITC Kabel Ultra

Insignia Alternate

Adobe Garamond
Alternate Italic

Frutiger

Gill Sans

Arnold Böcklin

Erbar Light

ITC Ozwald

Broadway

THE LETTER

Over four thousand years ago, just as today, people who couldn't write used a simple cross to sign letters and formal documents. The name of this almost universal symbol even meant "mark" or "sign." It's easy to assume that what has become a commonly accepted notation denoting a signature was the forerunner of our current X. Instead, what looked like an X to ancient writers actually gave birth to the Roman T.

Around 1000 B.C., the Phoenicians and other Semitic tribes were using a variety of crossed forms to represent the letter that they called *taw*. This letter, one of the first recorded, served two purposes: to represent the *t* sound, and to provide a mark with which those who could not write might sign their name to a document.

When the Greeks adopted the taw for their alphabet ten centuries later, they altered it only slightly so that it looked pretty much like our T does today. The *tau*, as they called it, was in turn passed on, virtually unchanged, from the Greeks to the Etruscans, and finally to the Romans.

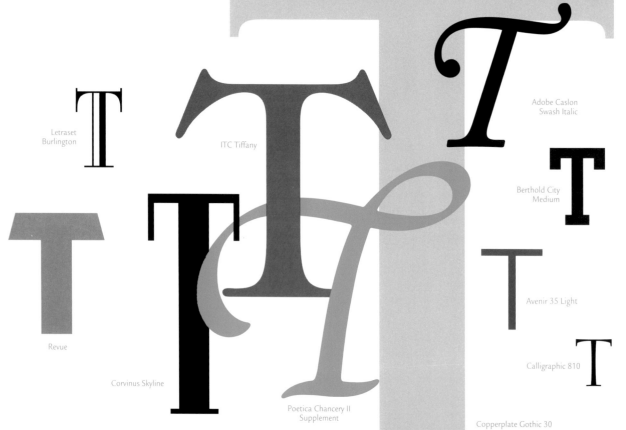

Letraset Burlington

ITC Tiffany

Adobe Caslon Swash Italic

Berthold City Medium

Avenir 35 Light

Revue

Corvinus Skyline

Calligraphic 810

Poetica Chancery II Supplement

Copperplate Gothic 30

On the surface, the T appears to be a very simple, straightforward letter. In a typeface like Helvetica or ITC Avant Garde Gothic, it can be. In many other faces, however, type designers have shown that the T leaves plenty of room for artistic expression.

The T normally occupies about two-thirds of an em space, or about the same space as the N or U. Its cross stroke can be symmetrical, as in Century Old Style, or slightly longer on one side, as in such calligraphic designs as Hiroshige.

The ends of the horizontal cross stroke in roman types may terminate with diagonally structured serifs, as they do in ITC Bookman or Caslon, or strictly vertical ones, like those in Bodoni. And sometimes the T's cross stroke serifs can be vertical on one side and diagonal on the other, as they are in ITC Garamond.

ITC Bookman Bodoni ITC Garamond

In handlettering there is even more leeway in the design of the letter T. Its elements can (and should) be adjusted so that the character will space properly and look proportionally correct in relation to adjacent letters. This means that the cross stroke will sometimes have to be lengthened, shortened, or designed to appear uneven or irregular. In some typefaces an alternate "tall" T is provided. This form of alternate letter creates drama and allows other cap letters to be kerned underneath it.

The T may appear to be a universally simple letter, but looks are often deceiving in type and typography.

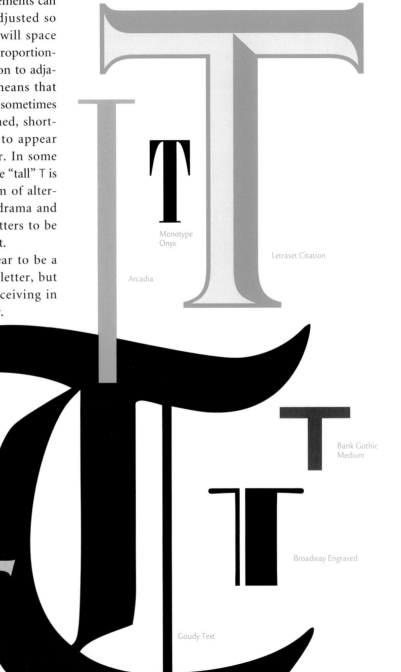

Monotype Onyx

Arcadia

Letraset Citation

Bank Gothic Medium

Broadway Engraved

Industria Inline

Friz Quadrata

Goudy Text

U
V
W
&
Y

The story of the U is also the story of our V, W, and Y. In fact, the story of our U begins further back, with the story of the sixth letter of our alphabet.

A creature called Cerastes, sort of a giant snake or dragon, was depicted as an Egyptian hieroglyph, which represented a consonant sound roughly equivalent to that of our *f*. This character was the forerunner of the Phoenician *waw*, the most prolific of all their letters. The waw gave birth to our F, U, V, W, and Y. It looked like our present-day Y and represented the semiconsonant sound of *w*, as in "know" or "wing."

At some point between 900 and 800 B.C., the Greeks adopted the Phoenician waw, using it as the basis for not one but two letters in their alphabet: the *upsilon*, for the *u* sound, and the *digamma*, for a sound that was roughly equivalent to our *f*.

The upsilon character was adopted first by the Etruscans, then by the Romans. They both used it to represent the semiconsonant *w* and the *u* sounds, but the form looked, again, more like a Y than either a U or a V. In ancient Rome the sounds of U, V, and W as we currently know them were not systematically distinguished; context usually determined the correct pronunciation. As a result, the Romans' sharp-angled monumental capital V was used to express the *w* sound in words like *VENI* (pronounced WAY-nee) and as the vowel *u* in words like *IVLIVS* (pronounced YEW-lee-us).

What happened to the Y? After the Romans conquered Greece in the first century B.C., they added the Greek Y to their alphabet for use in the Greek words they had acquired. The sound value attributed to it by the Greeks was unknown in the Latin language, and when the Romans used it in the adopted Greek words it took on the same sound as the letter I. The early English scribes frequently used Y in place of I, particularly when the minuscule i, which at that time did not carry a dot, appeared in close proximity to the minuscules m, n, or u. These characters were sometimes quickly written as a series of unconnected strokes, making it difficult for the reader to distinguish them.

In the medieval period, two forms of the U, one with a rounded bottom and one that looked like our V, were used to represent the *v* sound. It wasn't until relatively recently that the angular V was retained to represent our *v* sound, and the version with the rounded bottom was officially relegated to the single job function of representing the vowel *u*.

The graphic form of the W was created by the Anglo-Saxons around the thirteenth century. They called their new letter *wen*. This innovation arose from their attempts to distinguish the various sounds that were represented by the U. They used a V for both the *u* and *v* sounds, but wrote the V twice for the *w* sound. Eventually the two Vs were joined to form a single character. This early ligature endured to become part of the common alphabet. Rather than use what they considered to be an alien letter, the French preferred to double one of their own. They chose the U and called the letter *double V*, which the English called a "double U." The double V form is retained in typographic letterforms, but because of the need for speed in writing, the handwritten letter looks more like a double U.

The U is classified as a medium-width letter, but because it does not appear on the Trajan inscriptions it has no monumental model.

The U can be rendered in three different ways. The first is

u U U
Albertus Trajan Caslon 540

an enlarged version of the lowercase u, where the left stroke curves to meet a vertical right stroke. This design can be found in such typefaces as Albertus and Corvinus. In this configuration the right stroke also has a baseline serif that extends to the right. The second version of the U is symmetrical,

and can be seen in faces like Trajan and ITC Novarese. Here two equal-weight vertical strokes are joined by a baseline curve. Finally, there is the thick-and-thin version, in which the left stroke is heavy and the right stroke is a hairline. For examples of this treatment, look at faces like ITC Benguiat and Caslon 540. The thick-and-thin version, which has no bottom serif, is the most popular design.

The V is a medium-width character, about two-thirds as wide as it is high. In serif typefaces its vertex is almost always pointed, in which case the point must fall below the baseline at least as far as the rounded characters, ensuring a correct optical height and maintaining a strong baseline in text copy.

In ITC Tiffany and ITC Clearface, for example, the first stroke of the V drops below the baseline, and the second stroke joins it slightly above.

In some typefaces the parts of the serifs that extend into the counter are longer than those that face outward. This is

usually the designer's attempt to overcome some of the V's inherent spacing problems. For examples of this approach, look at Letraset's Caxton and ITC Century.

ITC Korinna

Bodoni Poster

Latin Extra Condensed

ITC Beesknees

Ariadne

Omnia

Shelley Volante

Cooper Black

Letraset Dolmen

Monotype Onyx

Senator Demi

ITC Berkeley Oldstyle

AG Book Rounded

X

Serifa

X

Adobe Caslon Swash Italic

Futura Extra Bold

Some could contend that our X is unnecessary. Fewer words in the English language start with the X than with any other letter, and its sound value is duplicated by both the *z* and the *ks* combination. The Phoenicians had no use for the *x* sound, many scholars contend that the Greeks didn't use the letter to represent a phonetic sound, and the Romans, who weren't exactly sure where to use it, stuck it at the end of their alphabet.

The Phoenician ancestor to our X was a letter called *samekh,* which meant "fish." Although some historians contend that the character instead represented a post or support, with only a slight stretch of the imagination it perhaps could be seen as the skeleton of a fish that has been suspended vertically.

As it turns out, the sound value of the samekh was not the same as our current X's. When the Greeks adopted the Phoenician alphabet, it seems that they had no need for all the characters representing sibilant sounds, so they acquired or modified only those that represented the sounds they used. The three Phoenician sound values that were difficult for the Greeks to pronounce (or assume as equivalents) were the *shin,* which represented the *sh* sound; the *tsade,* which represented the *ts* sound; and the ancestor of our X, the *samekh,* which represented the sharp *s* sound. Because none of the Phoenician letters represented the soft *s* that was predominant in their various dialects, the Greeks chose letters that represented the sound values closest to those they were familiar with and modified them slightly. For example, while the western (Chalcidian) Greeks chose the tsade, renamed it *san,* and attached to it the sound value of *ts,* the eastern (Ionic) Greeks adopted the shin, called it *sigma,* and attributed to it the sound value of *sh.* The samekh became the Greek *xi,* which had different sound values in the two Greek alphabets.

Inconsistencies in Greek pronunciation and in the usage of some letterforms was a direct result of geographical and political disunity. Of the many dialects and variations in letterform shape and sound values, the two main alphabet subgroups were the Ionic and the Chalcidian. By 400 B.C., the Ionic alphabet, which had been officially sanctioned at Athens, eventually became what is now known as the classical Greek alphabet. The Chalcidian alphabet, the alphabet of several western Greek colonies that were subsequently established in southern Italy, influenced several Italian writing styles, including Umbrian, Oscan, and Etruscan. Native Etruscan politics, culture, and art developed largely as a consequence of the Greek colonization of southern Italy, and although the Etruscans eventually halted subsequent Greek expansion into northern Italy, they adopted many of the Chalcidian Greek customs and practices.

The Romans appropriated the *x* sound from the xi of the Chalcidian alphabet and represented it with the *chi* of the Ionic alphabet, which consists of two diagonally crossed strokes. This letter, which was added to the Ionic alphabet around 500 B.C., became the prototype for both the capital and lowercase X we use to this day.

If the X were designed as a truly symmetrical letter, it would appear to be upside down. As with most letters the X is constructed to appear "correct," when mathematically it might not be.

The diagonal strokes of the letter actually cross just slightly above its true center, making the upper part smaller than the lower. This gives the character a firm foundation on which to stand, and helps the eye move across the page. Another trick designers use is to make the outside serifs longer than those on the inside of the character, which also enhances the letter's stability and legibility.

In serif designs, the seven to one o'clock stroke is lighter and usually a little more oblique than the other diagonal—again, to make things look "right," which in the X's case means symmetrical. Finally, the width of the X should be only one-half to three-quarters (at most) of its height. If an X is too wide it will look ungainly and arrest the smooth flow of the reading process.

Although Xs are constructed of only two diagonal strokes, there is a surprising diversity in their design. The X in ITC Zapf

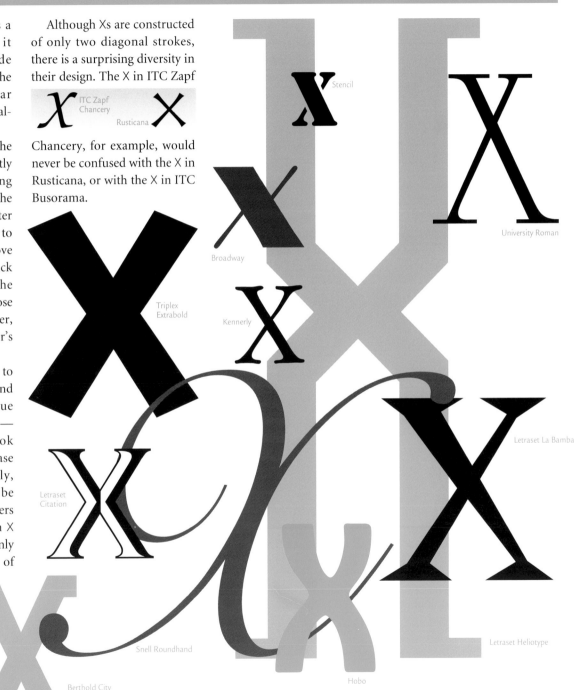

Chancery, for example, would never be confused with the X in Rusticana, or with the X in ITC Busorama.

ITC Zapf Chancery

Rusticana

Stencil

University Roman

Broadway

Triplex Extrabold

Kennerly

Letraset La Bamba

Letraset Citation

Letraset Heliotype

Snell Roundhand

Hobo

Berthold City Medium

The Letter

Z

The twenty-sixth letter of our alphabet was the seventh in the Semitic. They called the letter *za* (pronounced ZAG), which meant "weapon," and drew it as a stylized dagger. The Phoenicians used roughly the same sign, which they called *zayin* and which also meant "dagger" or "weapon." Similar symbols were used in other cultures, all of which had the same meaning but expressed a variety of sound values.

Around 1000 B.C., the Phoenician zayin was adopted as the Greek *zeta*. While the zeta looked more like a dagger than the zayin did, it did not look like the Z we currently use. Actually, it looked more like our capital I set in a slab serif typeface.

The Romans incorporated the zeta into their alphabet, but since the sound it represented was not generally used in Latin they eventually dropped it, bestowing its position of seventh letter on the G. In fact, the only reason that the Z is still in our alphabet is because the Romans later found that they needed it to write a few Greek words that they had incorporated into their language. Because it was an after-

thought, or at least not indigenous to the Latin language, the Z was relegated to last in alphabetical sequence.

The Romans used the capital I form of the letter in their monumental inscriptions, although it was not recorded on the famous Trajan column (no Greek words there). It is only when the letter was written by scribes and calligraphers that the top and bottom strokes were offset from each other and connected by what became a diagonal, rather than vertical, stroke. The reason for this design change? Probably because it was quicker and easier to write that way. The lowercase z is just a smaller version of the capital.

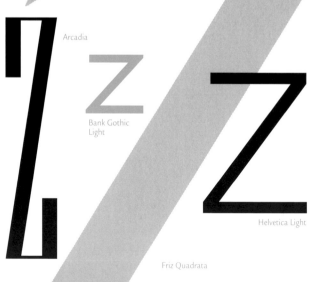

Arcadia

Bank Gothic Light

Letraset Follies

Friz Quadrata

Helvetica Light

Although many wouldn't notice it, the Z appears in two forms. If drawn with a chiseled-edged pen or broad, flat brush held in a natural position, the horizontals would be thick and the diagonal would be thin. The Zs in such typefaces as Trajanus and Goudy's Kennerly are designed in this manner.

Z Kennerly

Baskerville Z

Many designers and lettering artists, however, find this horizontal emphasis unsatisfactory and the resulting weak middle stroke unattractive, and as an alternative design the letter technically incorrect but, to their eyes, optically more comfortable. Typefaces as diverse as Baskerville and ITC Benguiat have this kind of reverse weight stress. Most serif typefaces are also constructed with the latter kind of Z.

The Z is not a "square" letter, but is about three-quarters wide as it is high. The horizontal strokes are usually the same length, but in some designs the top horizontal is slightly shorter than the bottom one, to give the letter a firm foundation on which to rest. In roman typefaces the Z is left pretty much alone, and tends to be one of the more conservative letters. In italic designs, however, the type designer quite often takes some creative liberties and concludes the lower horizontal in a delicate flourish, or perhaps a full-fledged swash.

Geometric 415 Black

Smaragd

Manhattan

Diotima

Bodega Sans

Goudy Old Style

Albertus

Frutiger Black Italic

Minion Swash Italic

Aachen Bold

Cloister

Ariadne

THE LOWERCASE LETTERS

Elegant tools for communication that were wrought to command respect and attention for millenia, the capital letters designed by the ancient Romans were—and still are—perfect for inscribing on monuments. However, for the commercial documents, literature, correspondence, and even the grocery lists and graffiti that were as much a part of ancient Roman life as they are of life today, these letterforms were less than ideal. Think about it: How would you like to write your next memo or grocery list in slowly constructed capital letters? (Neither did the Romans.) Form, as always, follows function, and in due course the capital letters began to change to better serve these other, less monumental, purposes.

EASIER WRITING STYLES

While monumental inscriptions were created by stonecutters, graphic communication was produced by scribes. These were specialists hired to record all kinds of information on papyrus or other transient writing surfaces, and their writing tools gave them more freedom and flexibility than the stonecutters had with their carving implements. It is uncertain whether the scribes adapted the inscriptional capitals to meet their needs or developed their own writing styles first, but over a period of time three different forms of handwriting, or *hands*, emerged that replaced the formal capitals in everyday graphic communication. These three styles came to be known as the *square capitals*, the *rustic* or *simple capitals*, and *roman cursive*.

SQUARE CAPITALS

The square capitals are generally considered an attempt to copy inscriptional letters. This writing style was reserved almost exclusively for the production of the most formal books and documents. The precision and regularity of their forms shows that these letters were drawn slowly and carefully. Still, they were written more quickly and with a more flowing hand than was possible, or practical, in stone. As a result, even though the square capitals were rendered to resemble the capital letterforms, they differed significantly from the inscriptional forms.

Square Capitals

RUSTIC CAPITALS

The square capitals were proportionally wide, and the material on which they were printed, vellum, which was painstakingly prepared from calfskin, was expensive. Those who oversaw the production of books and documents realized that the costs for inscribing less important information could be reduced significantly if the writing were done in letterforms that were narrower and easier to draw, consequently saving both materials and time. What have come to be known as the rustic or simple capitals (*rustica* in Latin) were the eventual solution.

Rustic Capitals

ROMAN CURSIVE

Not all writing had to be fancy. Most of it, in fact, was used to record transactions, keep accounts, draft correspondence, and document other day-to-day business. The writing style used for these relatively mundane applications differed from both the square capitals and the rustic capitals. Roman cursive was the ordinary business and correspondence hand of the Romans until approximately A.D. 500. It was used for legal documents, notices posted on walls announcing public games, signs advertising houses to let, and other com-

monplace interchanges. Since these kinds of writing were not usually intended to be permanent, they were often scratched in wax tablets, in clay, or on masonry, or written on papyrus. Sometimes they were so carelessly written that the result was an illegible scrawl. In spite of this, the very speed and carelessness with which these letters were written led to the present forms of many of our small letters. The roman cursive form was characterized by the tendency of the writer to keep the pen on the papyrus as much as possible while writing; hence the term "cursive," which literally means "running." That is, cursive writing reflected the feeling of a hand moving across the page as it created the letterforms. An important innovation of the roman cursive hand was the tendency toward creating ascending and descending parts on some of the letters. This probably came about because it was easier to make longer stems when writing quickly, as opposed to the precise, short lengths used in more formal and more slowly written documents. Although the scribes were not aware of it at the time, the ascenders and descenders they incorporated into this casual writing style helped establish an important departure in design from the capital letterforms.

While the three original Roman hands were used for almost 500 years, two events shortly following their development led to some additional, and quite different, styles of calligraphic writing.

Roman Cursive

LETTERS FOR BOOKS

In addition to being a military and political juggernaut, ancient Rome was also a major literary force. The Romans became the first major producers of written documents. Plays and poems were written, philosophical treatises were published, and, once Christianity became Rome's state religion, Bibles and religious commentaries were needed for scholars and missionaries. All this created great volumes of work for the scribes, which in turn spawned two new styles of writing: *uncials* and *half-uncials*.

UNCIALS

Uncial letters grew out of an effort to develop a beautiful formal writing style for Bibles and other important books. The dilemma facing the scribes was that the square capitals used for the most formal books were costly to produce, and that the *rustica* were not elegant enough for formal documents. Applying the lessons they had learned from the cursive hand to the square capitals, the scribes eventually achieved the rounded forms of the uncials.

Uncials were used for fine calligraphy from the fourth to the ninth centuries A.D. Usually a square-nibbed quill or reed pen was used to create them. Uncials are especially important because they are the first obvious step toward the creation of our current lowercase alphabet. Rounder shapes for the A, D, E, H, and M evolved. Try writing a capital A quickly in one motion, or an H or an M, and you'll begin to see how our lowercase forms became the "little brothers" of the roman capitals.

Many scholars, referring to St. Jerome's first use of the word, explain the term "uncial" as indicating letters one inch in height. *Uncia*, which means "one-twelfth" in Latin, was a unit of measure used by the Romans that is roughly equal to an inch. The problem with this generally accepted interpretation is that there were no uncials of that size in the manuscripts of the period. Hindsight suggests that St. Jerome probably meant merely "large letters" when he coined the term.

Uncials

Early in the sixth century, a writing style now known as the half-uncial came into general use. Despite its name, this style did not evolve from the uncial, but developed at the same time, out of the need for an easier, more condensed, and more readable writing style for secular documents. The half-uncials embodied further advances toward our lowercase letters, as the scribes took more and more liberties with the capital letterforms. In fact, the half-uncials are often categorized as small letters, and some claim that they represent the invention of the first lowercase alphabet. Except for the letters J, U, and W, the basic Latin alphabet was established by that time. But the widespread adoption of small letters in a uniform way was quite another matter. In fact, matters got worse before they got better. What uniformity in lettering there was began to disappear in the fifth century, following the disintegration of the Roman Empire.

Half-Uncials

NATIONAL HANDS

As Christian missionaries spread out over Europe from Rome, they carried with them Bibles and other religious writings. The missionaries soon had local monks at work producing new copies in the monasteries they established. The uncials and half-uncials generally served as the basis for the letters used to copy the manuscripts, but the monks were influenced by local tastes, customs, art, and styles of decoration. Out of this mixture came what we today call the various "national hands." These styles of writing were particular to each geographic location, and although they are referred to as "national," many times writing styles varied within just a few miles of each other.

The most beautiful of the national hands was the Irish. Because Ireland had never been occupied by the Romans, its predominant writing style exhibited no direct influence of the Roman hands. St. Patrick is credited with introducing this writing style to the tiny island country. The Irish hand in turn influenced the Anglo-Saxon national hand, when Irish missionaries traveled into Scotland in about A.D. 650. One of the most beautiful works of calligraphic art, *The Book of Kells,* was produced in the Irish hand in about A.D. 800.

Irish National Hand

A POINT OF DEMARCATION

When Charlemagne ascended the throne of the Holy Roman Empire in the late eighth century, he expanded reforms begun earlier by his father, Pepin, and intended to implement sweeping changes in learning and civic life. During a visit to Parma, Charlemagne met Alcuin, a well-known English scholar. Impressed with Alcuin's scholarship, Charlemagne invited him to organize the educational system of his domain. Alcuin accepted the challenge and began his task by standardizing a copying style for the many new versions of the Vulgate Bible that were required. One of the results of the search for a clear copying style was the Caroline minuscule, the forerunner of our own modern lowercase letters.

Caroline Minuscules

In general, the Caroline minuscules eliminated cursive forms and avoided ligatures, making letters independent of one another. When ligatures were used, they resulted in only slight changes in form. Also, these letters were drawn more full-bodied than their predecessors. All these characteristics adapted themselves easily to the invention of movable type by Johann Gutenberg in the mid-fourteenth century.

THE DESIGN OF THE LOWERCASE LETTERS

One of the first decisions a type designer makes when designing a lowercase alphabet is its x-height: How tall should letters like a, c, i, m, n, o, and x be in relation to

the capitals? Some typefaces, like Nicholas Cochin, have very small x-heights, while others, such as Americana and Antique Olive, have x-heights whose proportions border on the heroic. Old style designs tend to have relatively small x-heights, while those of more recent designs are generally larger. During the 1960s and '70s it was popular to design typefaces with exceptionally large x-heights. The theory was that since lowercase letters were the most important for text composition, the bigger they were, the more readable the typeface would be. The premise of the argument is sound—over 90 percent of text composition is set in lowercase letters—but the inference is not necessarily true. If the lowercase alphabet's x-height becomes too large, readability can actually be impaired. A general guideline for computing a sensible x-height is that it should be between 56 and 72 percent of the height of its capital letters.

Next, the designer establishes the height of the ascenders and the length of the descenders. These measurements can be the same, though sometimes ascenders are longer than descenders. In some alphabets the ascenders are the same height as the capitals, but in many instances they are slightly taller.

Finally, the designer determines the weight of the characters—one of the most important decisions he or she makes. If over 90 percent of the letters we read are lowercase, then their weight and how they "color" a page are critical to the overall design of a typeface.

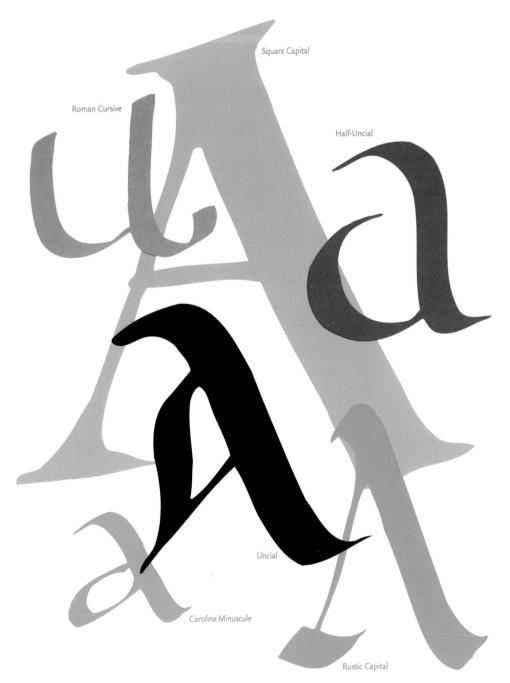

Roman Cursive

Square Capital

Half-Uncial

Uncial

Caroline Minuscule

Rustic Capital

THE LETTER

The lowercase a can take two forms: the single-storied design found in typefaces such as Futura and ITC Avant Garde Gothic, and the two-storied design based on traditional roman letterforms.

Futura Book

Helvetica

The single-storied design does not allow much latitude for creativity. In this configuration the a is basically a round shape, usually appearing geometrically accurate, that is connected to a stem equal to the x-height of the typeface. The type designer must ensure that the point where the bowl meets the vertical does not become optically heavy. This is usually accomplished by lightening the round stroke as it advances toward the vertical.

The two-storied a design, which provides more room for artistic license, is also one of the most complicated letters to construct. The bottom of the two-storied a must have a strong optical foundation. This means that the top loop should be slightly narrower than the bottom bowl, which is generally about two-thirds of the letter's overall height. The vertical stroke either ends in a baseline serif or in a hook that drops slightly below the baseline.

Arcadia

Diotima

Duc De Berry

Aachen Bold

ITC Franklin Gothic Demi

Freestyle Script

Fette Fraktur

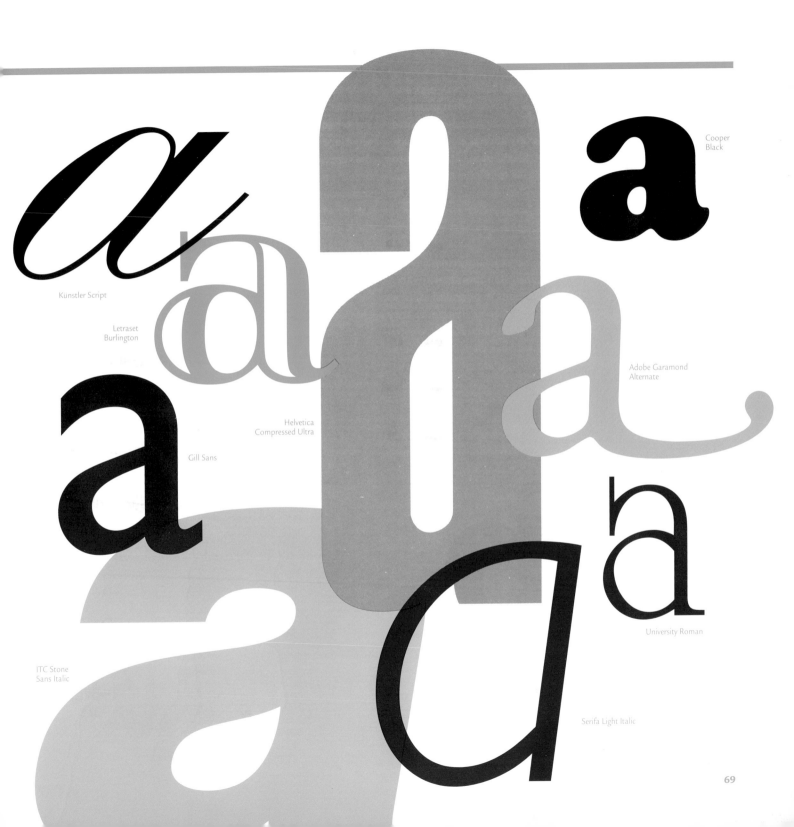

Künstler Script

Letraset
Burlington

Gill Sans

Helvetica
Compressed Ultra

Cooper
Black

Adobe Garamond
Alternate

University Roman

ITC Stone
Sans Italic

Serifa Light Italic

Although the letters b, d, p, and q share several design traits, the first rule in designing them is to avoid creating one "master" and flipping it around to make all four letters. While this

b d p q

Lowercase b flipped to make four letters

may seem logical from a typographic standpoint, it invariably results in poor design. In a well-conceived typeface, the designer takes great care to ensure that each letter has a firm foundation on which to rest. For the b, d, p, and q, this is achieved by making the bowls of the letters just slightly heavier—and sometimes imperceptibly flatter—on the bottom than they are at the top.

In contrast to those of the d and the q, the bottom curved strokes of the b and the p usually flare slightly as they join the vertical. In old style designs based on calligraphic forms, such as Stempel Garamond or Goudy Old Style, the bowls of the b and the p are heaviest at about four o'clock, while those of the d and the q are heaviest at about eight o'clock.

b p d q

Goudy Old Style

If the design is based on either traditional or modern letter-forms, the bowls tend to be heaviest at three and nine o'clock, respectively.

b p d q

Bodoni

While the bottom of the b's vertical stroke sometimes ends in a serif, as in ITC Benguiat or Bulmer, it might also terminate in a spur that doesn't quite extend below the baseline. The roman d, however, almost always has a bottom serif as a baseline terminator. The top of the vertical in the p echoes that of the d in that it also usually has a serif, while the top of the q's vertical ends either in a spur or in a serif.

Duc De Berry

ITC Korinna

AG Book Rounded
Bold

ITC Modern
No. 216 Light

Madrone

ITC Lubalin
Graph Book

Caslon Open Face

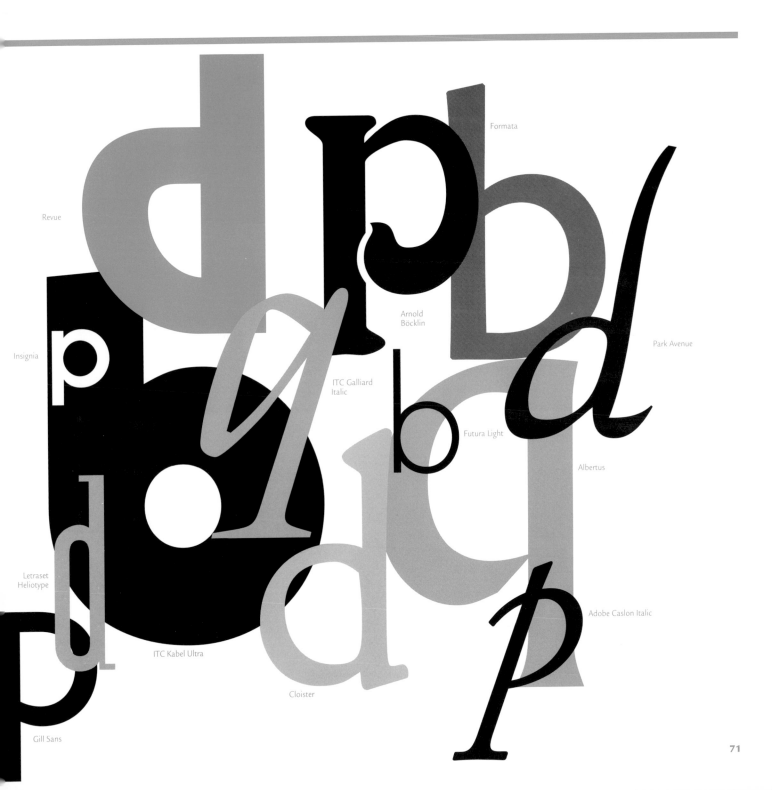

Revue

Insignia

Letraset
Heliotype

Gill Sans

ITC Kabel Ultra

Cloister

Formata

Arnold
Böcklin

ITC Galliard
Italic

Futura Light

Park Avenue

Albertus

Adobe Caslon Italic

THE LETTER

The letter c is not half an o. In roman faces the weight of the bowl's curve is carried further into the stroke, which gives it an optically firm foundation on which to rest. In addition, as the curve departs from the baseline on the right side it is less pronounced than on the left. This is much less apparent in sans serif faces, but nonetheless necessary to ensure that the letter does not look unstable.

For the same reason the top of the c's bowl should not be as wide as the bottom, a trait that is quite obvious in roman types but less so in sans serif designs.

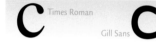

Times Roman

Gill Sans

Because the c's open counter can exaggerate its height somewhat, some type designers reduce its height to just slightly less than that of the o.

ITC Korinna

Broadway

Frutiger

Duc De Berry

Futura Extra Bold

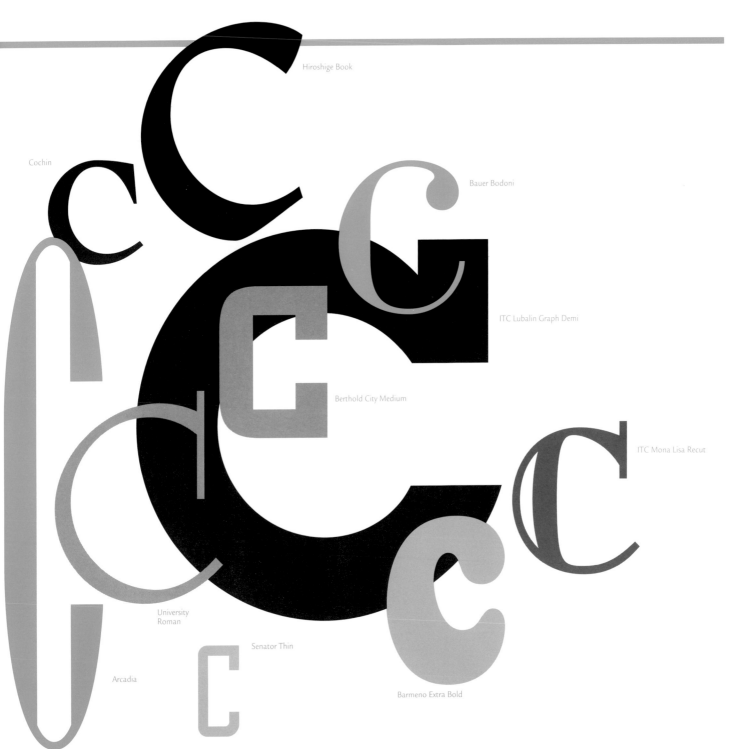

Hiroshige Book

Cochin

Bauer Bodoni

ITC Lubalin Graph Demi

Berthold City Medium

ITC Mona Lisa Recut

University
Roman

Senator Thin

Arcadia

Barmeno Extra Bold

In contrast to the c, the design of the e can be based on that of the o because it shares the same basic proportions and weight

o e

Bodoni

stress. The characteristic slanted crossbar of old style roman designs reflects the angle at which the chisel-edged brush is held if the character is drawn calligraphically. If the crossbar is horizontal to the baseline, it is almost always positioned slightly above the median point of the x-height.

AG Old Face
Shaded

ITC Avant Garde
Gothic Extra Light

Caslon 3 Italic

Monotype Onyx

ITC Serif Gothic

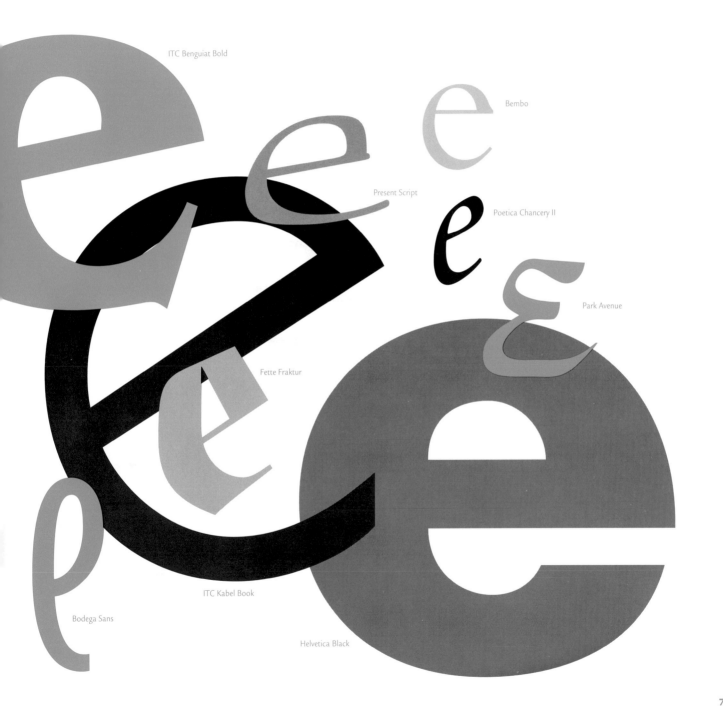

ITC Benguiat Bold

Bembo

Present Script

Poetica Chancery II

Park Avenue

Fette Fraktur

ITC Kabel Book

Bodega Sans

Helvetica Black

THE LETTER

The f is a narrow letter that can be exceptionally expressionistic in calligraphy and handlettering but somewhat problematic in type design. In calligraphy and handlettering, the top of the f can be modified to perfectly complement the character that immediately follows it. If the subsequent letter is an x-height character, the top of the f can be a graceful, full-bodied stroke. If it is an ascending character, the f can be modified to create a beautiful ligature.

Unfortunately, none of this is possible—or practical—in a typeface design. The f must be designed to work well with both x-height and ascending characters. Ligatures in some fonts may help to remedy several of the awkward combinations, but the design of the f must always be considered carefully.

The f's crossbar is almost always a hairline stroke that aligns with the typeface's x-height. In order to counterbalance the weight of the top bowl, in some designs the crossbar is longer on the right than it is on the left.

Triplex Extrabold

Letraset
Burlington

Bembo Italic

Helvetica Black
Condensed

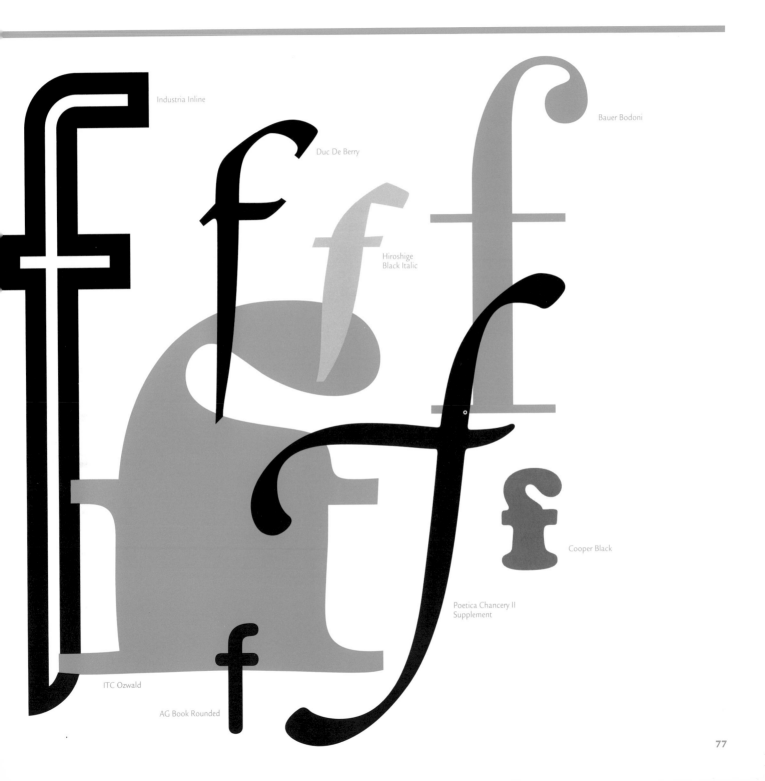

Industria Inline

Duc De Berry

Bauer Bodoni

Hiroshige
Black Italic

Cooper Black

Poetica Chancery II
Supplement

ITC Ozwald

AG Book Rounded

THE LETTER

g

The letter g can take two forms: the single-storied design that most of us were taught to make in elementary school, and the two-storied design that is common to serif type designs.

g *Helvetica*

Formata **g**

In the single-storied design, the top of the stem terminates either in a right-facing serif or in a spur that aligns with the mean line of the x-height. This g's loop, which is somewhat narrower than its top bowl, falls imperceptibly short of the descender line.

The more common two-storied design is comprised of a bowl, a loop, and a graceful link between the two. The bowl is a miniature version of the typeface's o, and should have the same weight stress. The loop drops down slightly below the descender line, and the link between the two can be either on an almost vertical plane or on a descending angle. The bowl of this g usually has a projecting ear that might appear as an upward curl, a downward curve, or a straight line.

Monotype Onyx

ITC Avant Garde Gothic Extra Light

ITC Ozwald

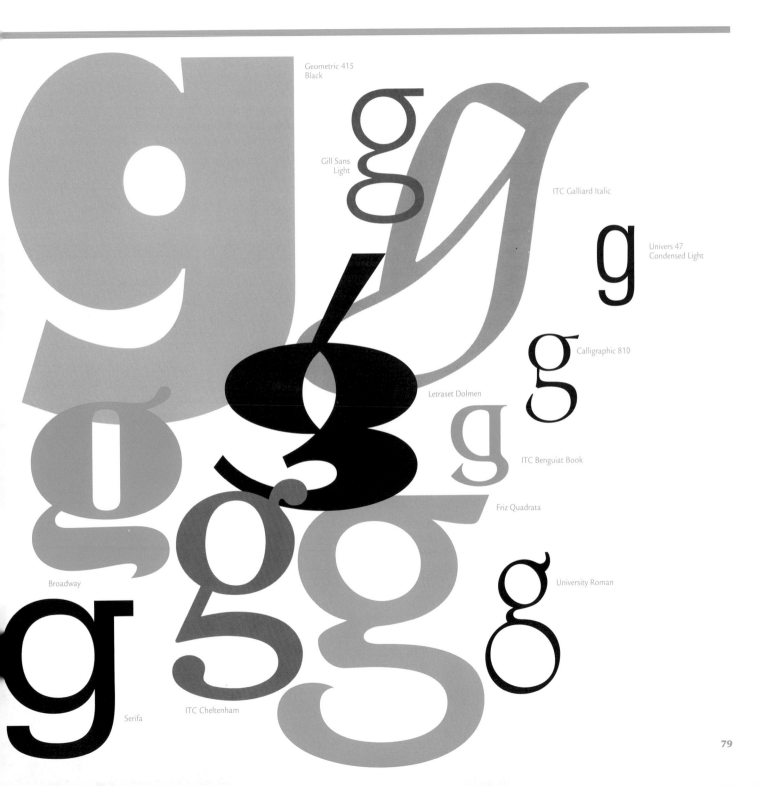

Geometric 415
Black

Gill Sans
Light

ITC Galliard Italic

Univers 47
Condensed Light

Calligraphic 810

Letraset Dolmen

ITC Benguiat Book

Friz Quadrata

Broadway

University Roman

Serifa

ITC Cheltenham

While the h and the n are quite similar in design, it should be noted that the m is not a double n. The n is traditionally one of the key letters in the development of an alphabet design. It sets the lowercase stroke width, the serif structure (in a roman design), and the spacing relationships for characters with straight vertical sides.

The baseline serifs on these letters nearly always point both left and right on all strokes. ITC Century is a notable exception to this rule: The center stroke of its m has only a one-sided serif in an attempt to keep the "color" of the face even. The

Baskerville
ITC Century

weight of the vertical stroke in old style designs is carried further into the shoulder than it is in transitional and modern typeface designs.

ITC Fenice Light

A brief note on the m: When the Greeks adopted the Phoenician *mem*, they converted its soft round shapes into angular ones and renamed it *mu*. The Greek mu was acquired first by the Etruscans, then by the Romans, both of whom essentially left it alone. Sometime around the third or fourth century A.D., the rounded form of the m reappeared on the scene once again, though it was almost lost in succeeding years. Probably because the m is one of the more complicated and time-consuming letters to write, it became common practice among medieval scribes to place a stroke over the preceding letter instead of actually writing the letter m. Thus, for example, the word *exemplum* would be written as *exeplū*. This practice survived well into the seventeenth century.

Bodoni Italic

Corvinus Skyline

Americana Extra Bold

ITC Avant Garde
Gothic Book

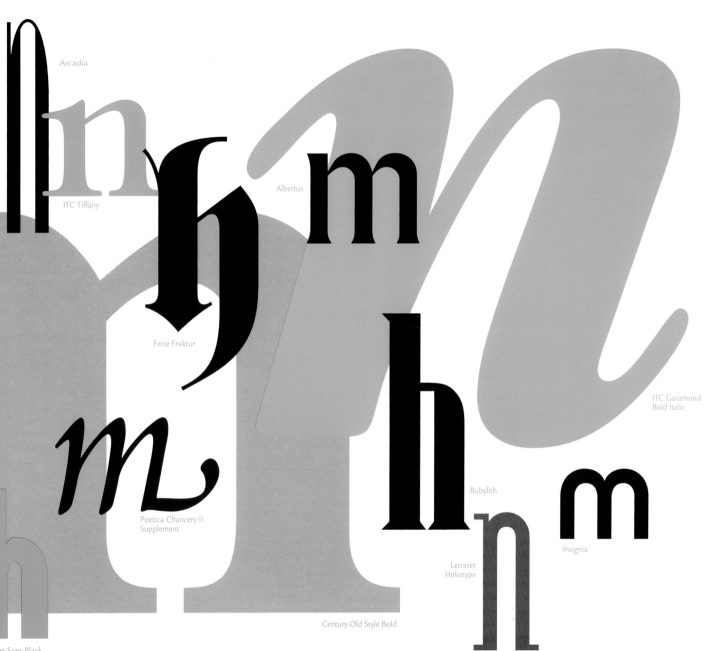

Arcadia

ITC Tiffany

Albertus

Fette Fraktur

ITC Garamond
Bold Italic

Poetica Chancery II
Supplement

Rubylith

Century Old Style Bold

Letraset
Heliotype

Insignia

ga Sans Black

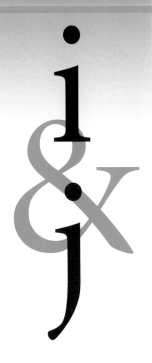

The lowercase i is a relatively easy letter to design, but the j's simple appearance can easily misrepresent the task at hand. Once the stem weight and serif structure have been established for the lowercase characters, designing an i is pretty much limited to assembling its various elements. The only part of the character that requires some thought is the dot.

There are two theories as to how the i and j obtained their dots. One suggests that the j got its dot first, around the thirteenth century, in an attempt to further distinguish it from the i. The other theory states that the i got its dot first (at about the same time), not only to indicate its phonetic difference from the j but to help distinguish it from characters like m, n, and u, which at the time were drawn as a series of simple vertical strokes.

The dots of is and js must convey the same weight optically as the stems. They should also be close enough to the stem that they do not appear to float in space, but not so close that they crowd the principal part of the letter in text composition. While most dots are positioned directly over the stem, in some old style designs like Deepdene and Lutetia the dot is offset to the right as if it had been jotted quickly as the hand rushed on to make the next letter. Some designers feel

i Adobe Garamond
Deepdene i

that offsetting an i's dots can help the reader by emphasizing the left-to-right movement across the page.

With the lowercase j, type designers have tails to contend with. Generally the j's tail is devised as an upside-down mirror image of the f's bowl, but designers would be short-changing the j if they actually handled it that way. If a designer were to base the j on the f, the weight of the vertical stroke would have to be increased slightly to make it consistent with those in other characters. In addition, the top of an f is usually wider than the bottom of the j.

New Caledonia Italic

Baskerville Italic

Futura Extra Bold

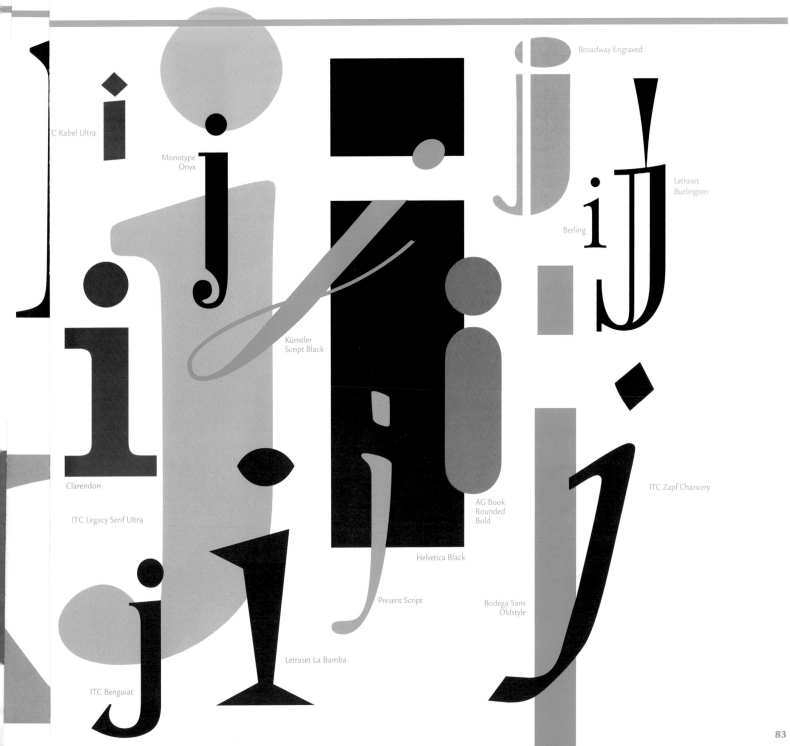

ITC Kabel Ultra

Monotype Onyx

Künstler Script Black

Clarendon

ITC Legacy Serif Ultra

ITC Benguiat

Letraset La Bamba

Present Script

Helvetica Black

AG Book Rounded Bold

Bodega Sans Oldstyle

Broadway Engraved

Letraset Burlington

Berling

ITC Zapf Chancery

o

From a type designer's standpoint, the lowercase o is one of the most important letters, setting the standard for the weight and stress of round strokes, the spacing of other rounded lowercase letters, the relationship of stroke to counter, as well as the thickness of the lowercase hairline.

In typefaces dominated by old style or calligraphic design traits, the o's bowl is heaviest at approximately eight and two o'clock, reflecting the angle at which a chisel-tipped brush is held when the letter is drawn.

o Bembo ITC Fenice o

In typestyles that reflect more modern influences, the weight stress of the o and other round characters shifts toward the vertical. For instance, in faces like Bodoni and ITC Fenice, the weight stress of the o is absolutely vertical.

Letraset Fashion
Compressed

ITC Avant Garde Gothic
Extra Light Oblique

Hiroshige Bold

Eurostile Extended No. 2

Letraset
Heliotype

Hobo

ITC Weidemann
Book Italic

ITC Grizzly

Revue

Futura Extra Bold

Letraset
Dolmen

89

THE LETTER

r

The letter r is composed of a vertical stroke that mimics the first stroke of an m or an n, and a tail or flag where their shoulders would slope into the next vertical. In most designs the tail of the r is modeled after the ear of the g, but in revival typefaces like Belwe and ITC Berkeley Oldstyle these two elements differ dramatically.

gr
Century Old Style

gr
ITC Berkeley Oldstyle

In calligraphic designs the end of the flag reflects the natural termination of a brushstroke, while in constructed designs it is either a ball or pear-shaped terminal. In some typefaces, the size of the r's flag is reduced to improve its spacing relationships with adjacent letters. In others, like Cochin, the r's tail is full-bodied, and might even be described as flamboyant.

r
Bodoni Open

r
AG Book
Rounded Bold

r
Arcadia

r
Cochin

r
Poetica Chancery II
Supplement

r
Gill Sans

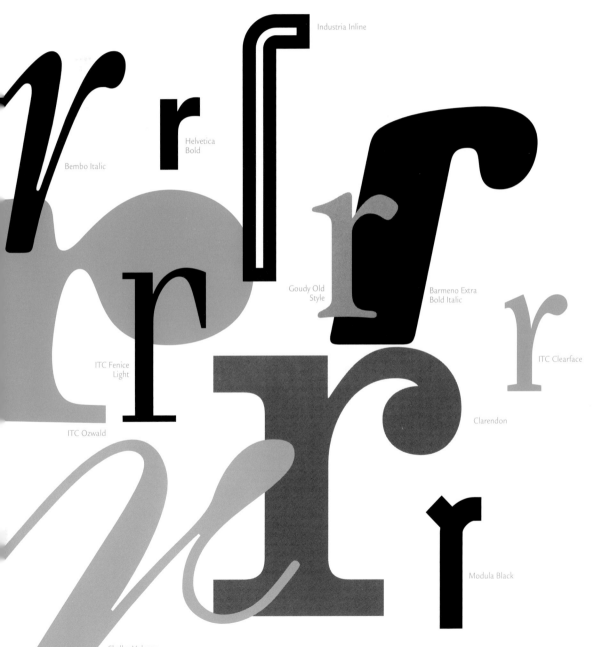

Industria Inline

Bembo Italic

Helvetica
Bold

Goudy Old
Style

Barmeno Extra
Bold Italic

ITC Fenice
Light

ITC Clearface

ITC Ozwald

Clarendon

Modula Black

Shelley Volante

The lowercase s is a scaled-down version of the capital letter. It is a narrow letter, its width being about half its height. Since it is a round letter and would appear short otherwise, it is usually designed to slightly overlap the established x-height and baseline.

To provide the s with a firm foundation on which to rest, the optical center should be drawn above the true center of the character, making the upper half of the letter appear smaller than the lower. In some

ITC Serif Gothic

Albertus

typefaces, like Trajanus and Albertus, this configuration is reversed, but this treatment should never be accentuated to the extent that the letter appears to be upside-down.

Broadway Engraved

Triplex
Condensed
Serif Black

Berthold Script

ITC Modern
No. 216 Light

Arcadia

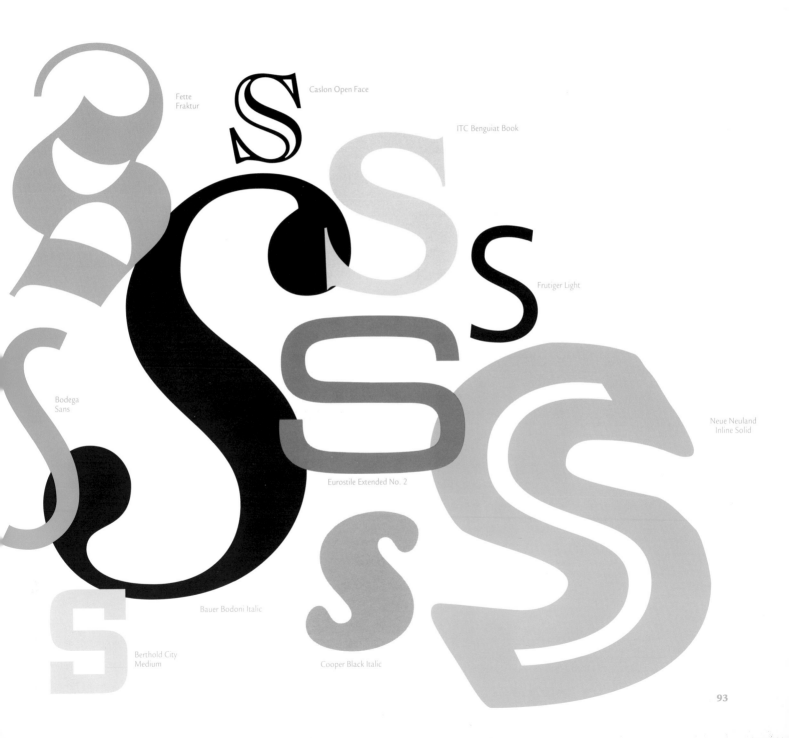

Fette
Fraktur

Caslon Open Face

ITC Benguiat Book

Frutiger Light

Bodega
Sans

Neue Neuland
Inline Solid

Eurostile Extended No. 2

Bauer Bodoni Italic

Berthold City
Medium

Cooper Black Italic

THE LETTER

t

Even in the most mundane of typefaces, the lowercase t can be a very distinct letter. It can vary widely in height, from just above the x-height to just slightly below the full height of the ascenders. The t's crossbar is usually aligned with the mean line of the x-height, although it can also work just as well slightly below it.

The top and base of the t can be handled in a number of different ways. In many typefaces the t's top ends in a point with bracketing back to the crossbar on the left side, in others it is clipped at a pronounced angle, and in still others it is simply flat. The base of the t can also appear flat, as it does in Americana; as a soft curve, as in Garamond; or as a very tight hook, as can be seen in Clarendon's t.

t — Americana

t — Adobe Garamond

t — Clarendon

Kaufmann

Cosmos Extra Bold

Blackoak

Berthold City Bold

Berling

Futura Light

Monotype Onyx

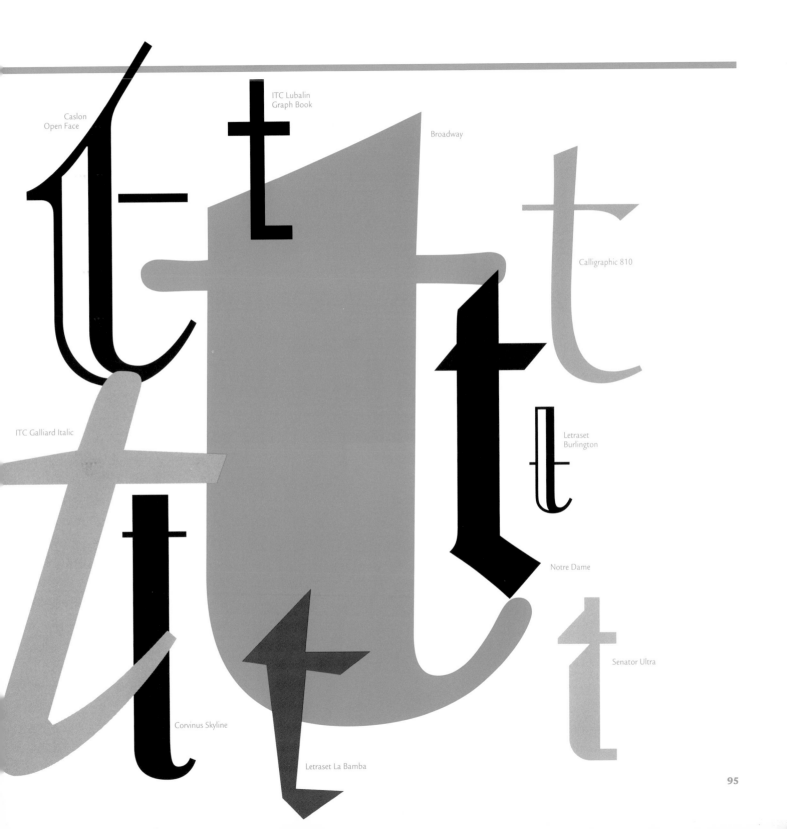

Caslon
Open Face

ITC Lubalin
Graph Book

Broadway

Calligraphic 810

ITC Galliard Italic

Letraset
Burlington

Notre Dame

Corvinus Skyline

Senator Ultra

Letraset La Bamba

THE LETTER

u

Lowercase us are not upside-down ns. In old style designs the u's top serifs are flag- or pennant-shaped, mimicking the start of a vertical stroke as it would be rendered with a chisel-tipped brush. The weight stress of the curve at about seven o'clock and the part of the stroke that is just slightly heavier than the hairline that connects the shoulder to the left vertical of the m or n also reflect that influence.

Although the us in most roman typefaces have parallel, left-pointing top serifs, there are some in which full serifs sit atop its vertical strokes, and rarer still are those whose two top serifs do not match or point in different directions.

ITC Fenice Rubylith Bodega Serif

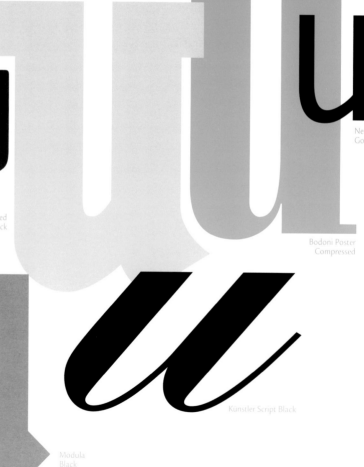

Barmeno

Triplex Condensed
Serif Black

Bodoni Poster
Compressed

News
Goth

Kunstler Script Black

Modula
Black

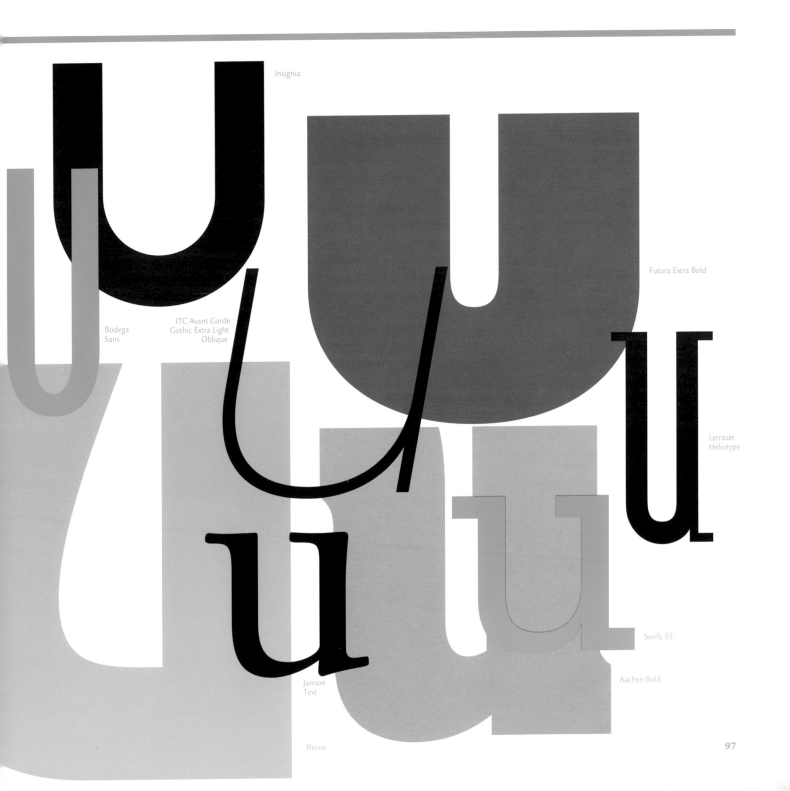

Insignia

Futura Extra Bold

Bodega
Sans

ITC Avant Garde
Gothic Extra Light
Oblique

Letraset
Heliotype

Serifa 55

Aachen Bold

Janson
Text

In most type designs, lowercase v s, ws, and xs are scaled-down versions of their capital letterforms. They share the same design traits, and their serif structures are almost always the same.

Just about the only time there is a significant design difference between the capital and the lowercase versions of these letterforms is when the capital W is of the overlapping V variety, a trait that is very seldom seen in its lowercase version. In old style designs that recall the influence of the calligrapher's brush, the v, w, and x sometimes lack the inside serif on heavy diagonal strokes. And in revival faces like ITC Benguiat, the point where the diagonals join sometimes lacks a serif altogether.

Some xs look like simple crossed ls, while others, like those in Walbaum Italic and ITC Century Italic, appear to be made from flip-flopped cs. Actually, italic xs provide type designers with many creative opportunities. Consider Hermann Zapf's x design in ITC Zapf Book Italic, or the x that Georges Auriol created in the italic variant of his eponymous type design.

The design of the lowercase y is for the most part based on that of the v, although in some typefaces the point at which the y's two diagonal strokes meet occurs slightly above the baseline rather than slightly below it. The tail of the y is not generally a place where a type designer can get overly effusive. Since the y is an often-used letter, adding a fancy swash tail to it can negatively affect the overall readability of the typeface.

Weiss

Frutiger

Auriol

Broadway

ITC Kabel
Medium Italic

Friz Quadrata Bold

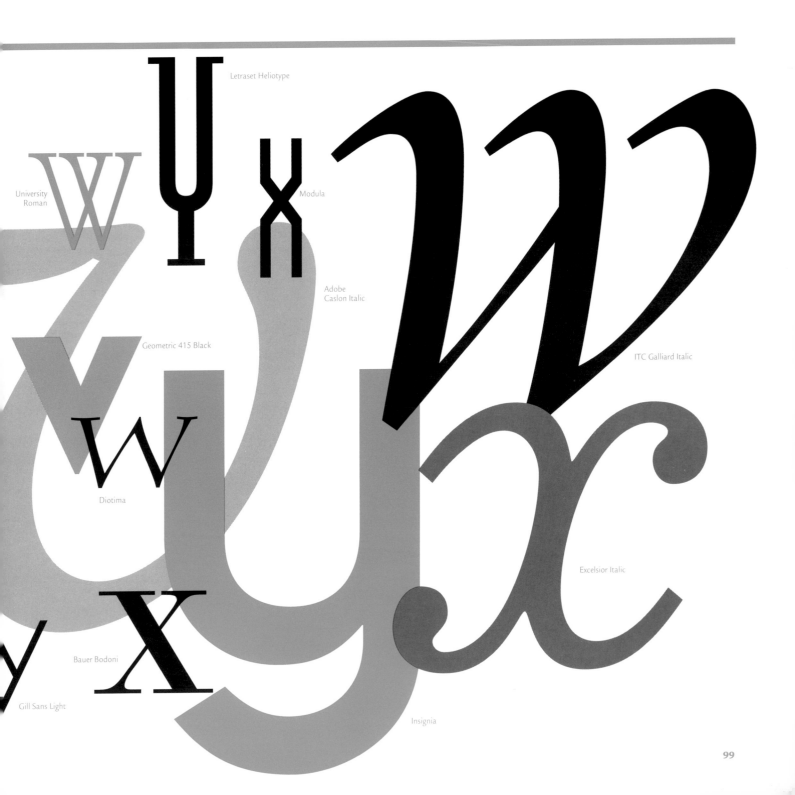

University
Roman

Letraset Heliotype

Modula

Adobe
Caslon Italic

Geometric 415 Black

ITC Galliard Italic

Diotima

Excelsior Italic

Bauer Bodoni

Gill Sans Light

Insignia

THE LETTER

z

The lowercase z is more or less a scaled-down version of the capital letter, though its proportions are a little wider. Type designers should ensure that its base is wide enough to optically support the stroke and counterbalance the top horizontal. The bottom hairline should also be slightly heavier than its top counterpart.

Caslon 540 Italic

Letraset Fashion Compressed

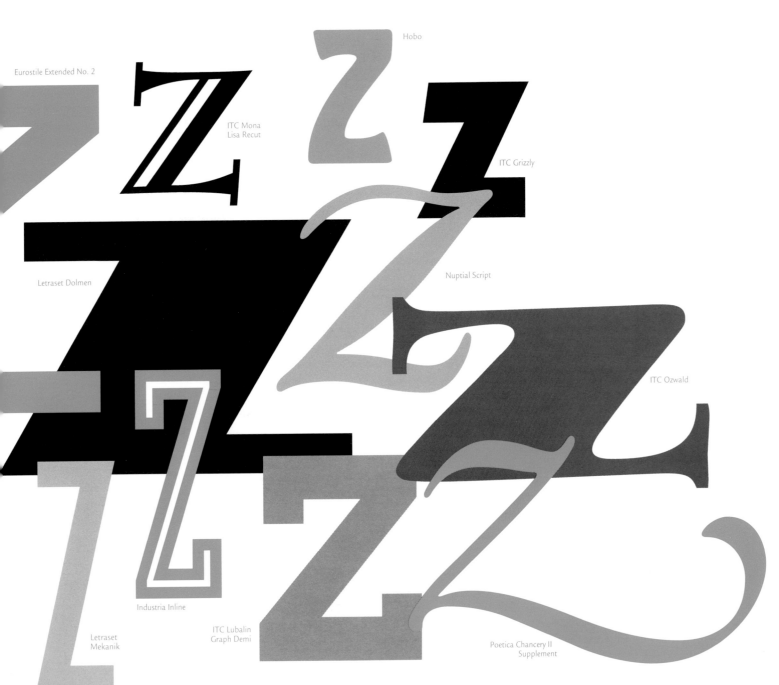

Eurostile Extended No. 2

Hobo

ITC Mona
Lisa Recut

ITC Grizzly

Letraset Dolmen

Nuptial Script

ITC Ozwald

Industria Inline

Letraset
Mekanik

ITC Lubalin
Graph Demi

Poetica Chancery II
Supplement

THE AMPERSAND

A relatively technical craft, typeface design is primarily concerned with producing a series of interchangeable tools that always work in harmony regardless of how they are combined. For the most part, this puts a real damper on how creative a designer can get when it comes to rendering individual letterforms. There are, of course, some exceptions to this rule, and the ampersand is a shining example.

Derived from the Latin *et* (which means "and"), the ampersand is a ligature comprised of the letters e and t. The word "ampersand" itself is an alteration of *et* (&) *per se and,* which was subsequently corrupted to "and per se and," then finally "ampersand." The invention of the ampersand is sometimes credited to Marcus Tiro, who in 63 B.C. made it a part of his shorthand system of writing. Another source sites that it wasn't until about A.D. 45 that the ampersand, written in the style of the early Roman capital cursive letters, first appeared on a piece of papyrus. Still another source points to Pompeian graffiti dated around A.D. 79 as the first use of the ampersand. Clearly, the exact birthdate of the ampersand will never be established.

As did many of the characters in our current alphabet, the ampersand probably began as a connivence. The Latin et was first written by scribes as two distinct letters, but over time the letters were combined into a monogram of sorts. Once accepted as a single character, artistry took over and a more flowing design resulted.

By the time Charlemagne's scribes developed the Caroline minuscule in about A.D. 775, the et ligature had become a standard part of their repertoire. The ampersand was then adopted with the invention of printing in the mid-fifteenth century, after which it became a commonly used character for about a hundred years. For example, a single page from Francesco Colonna's *Hypnerotomachia Poliphili,* printed by Aldus Manutius in 1499, has twenty-five ampersands. The reason for a more liberal use of the ampersand in early printing is two-fold: First, early printers wanted their work to reflect the traditions of hand-illuminated manuscripts (a common technological phenomenon—the first automobiles looked like horse-drawn carriages, and the first television shows weren't much more than radio programs with pictures); second, because then, as now, the ampersand was considered a particularly beautiful character that printers appreciated for its own aesthetic merit.

Unfortunately, the ampersand doesn't see much use anymore. It is usually confined to headlines and business stationery, where it dutifully yokes company names. Not everyone, however, agrees with this convention. In his "An Essay on Typography," Eric Gill wrote that "it would be a good thing typographically if, without any reliance upon medieval or incunabulist precedent, modern printers allowed a more frequent use of contractions. The absurd rule that the ampersand (&) should only be

used in business titles must be rescinded, & there are many other contractions which a sane typography should encourage."

Today the ampersand is a part of every new typeface design and is often exceptionally beautiful. Consider for example the ampersand in ITC American Typewriter. One would expect a fairly pedestrian, hohum ampersand in this face. Wrong. Not only does this font include a handsome design for the et ligature, it offers an alternate as well. Other great ampersands can be found in ITC Bookman, Adobe Garamond, Trump Mediaeval, and New Caledonia Italic (especially in the black weight). Some typefaces provide several ampersand choices: Goudy drew two for his Franciscan, ITC Bookman has three, and Cancelleresca Bastarda gives you a whole handful. If you really want a vast selection, try Adobe's Poetica by Robert Slimbach, which includes over fifty-eight ampersand designs!

Monotype Onyx

Pompeijana

Windsor Light

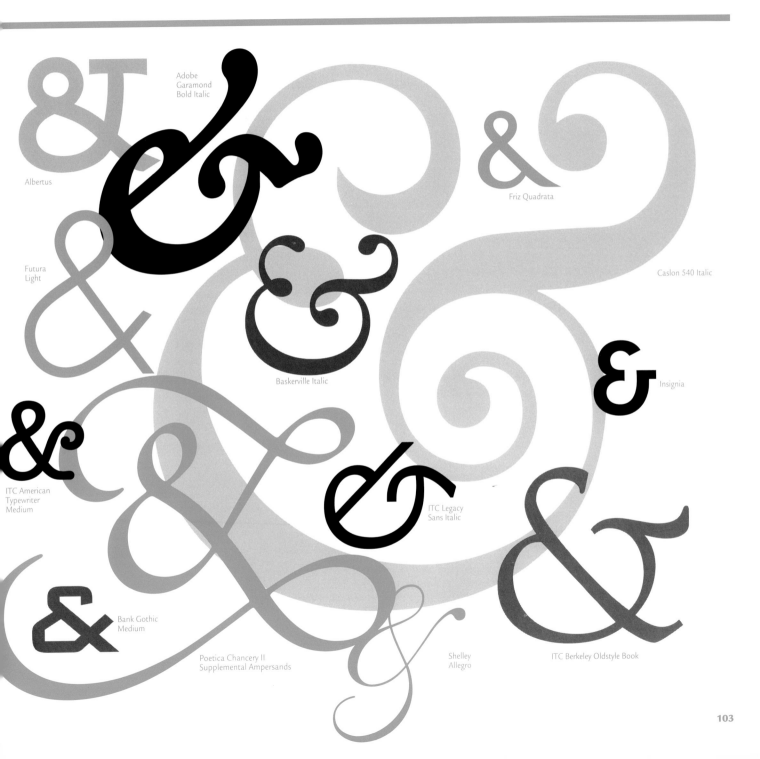

Adobe
Garamond
Bold Italic

Albertus

Friz Quadrata

Futura
Light

Caslon 540 Italic

Baskerville Italic

Insignia

ITC American
Typewriter
Medium

ITC Legacy
Sans Italic

Bank Gothic
Medium

Poetica Chancery II
Supplemental Ampersands

Shelley
Allegro

ITC Berkeley Oldstyle Book

THE NUMERALS

While our letterforms evolved from the Roman monumental letters, our numerals are Arabic in origin. The numerals that the Romans used were derived from their capital letterforms, and although they worked well within monumental inscriptions, large numbers expressed in Roman numerals are long strings of characters that are at best difficult to read, and at worst virtually impossible to use effectively in any mathematical computations.

When the lowercase alphabet became the standard for handwritten documents around A.D. 800, number values were still expressed in Roman numerals. The good news was that they were compatible with the lowercase letterforms, but they were still about as useful as mittens in August.

Classical Greece and Rome were renowned for their scholarship in history and literature, yet the centers for mathematical study were located in Asia and the Middle East. Early cultures searched for a numerical system that would work in a variety of situations, but the solution was hampered for centuries by the absence of a concept of zero. It wasn't until the sixth century A.D. that zero as a numerical value was developed in India.

Through their trade with India, the Arabs also adopted the concept of zero and became sophisticated mathematicians in their own right. For the most part, the numerals they used looked very much like the ones we use today, but it took many years for the Western world to incorporate these characters into printing and writing. As late as the twelfth century A.D., European numerals, except for the 1, the 8, and the 9, were different from the forms we use today. Commercial activity eventually resulted in the conversion from Roman to Arabic numerals, as merchants found the former too difficult to work with and prone to computational errors. As international trade expanded, so did the use of Arabic numerals.

When Gutenberg invented the art of typography, he designed a set of numbers to complement his original font. In spite of this precedent, for almost one hundred years afterward numbers were treated largely as pi characters that did not correspond to any particular typeface design. Claude Garamond, the celebrated sixteenth-century French type designer, is generally credited with creating the first typeface whose numerals were specifically designed to reflect the subtleties of its letterforms. Except for a few stylistic variations, Garamond's figures set the standard for numerals design for the next two hundred years.

Garamond intended his numerals to be set as part of text copy and designed them to have the same proportions as lowercase letters. Because of this, they do not align with the baseline and the cap line or ascender line of a given typeface, as do the numerals in most of the fonts that are available today. Corresponding to lowercase dimensions, Garamond's numerals are based on three forms: ascending (6 and 8), medial (1, 2, and 0), and descending (3, 4, 5, 7, and 9). To prevent readers from confusing the lowercase 0 with the lowercase o, the former was given a different weight stress.

In response to the documentation required by the many scientific advancements that were made during the Age of Enlightenment, in the late eighteenth century a new type of numeral, referred to as "lining" or "ranging," was introduced for mathematical and technical typesetting. The idea was that the larger figures would provide a more legible alternative to Garamond's design. Just as Garamond's numerals reflect the design and proportions of lowercase letters, lining figures correspond—visually if not actually—to the capitals' height, stroke weight, and proportions, although in some scripts and decorative faces they are often much shorter

than the capitals. When lining figures are designed to a common width so that columns of numerals will align, they are called "tabular" or "monospaced." This type of numeral also establishes the en space of a font. Lowercase or lining numerals whose design incorporates spacing that is sensitive to the proportions of the individual figures are called "proportional" or "fitted," and will not align when set in columns.

At first glance ranging numbers may appear to be more legible than their lowercase counterparts, but a variety of legibility studies have proven the opposite to be correct: Lowercase numbers are moderately more legible than ranging numbers when isolated, and considerably more legible when set in groups. In addition to being more legible, many designers and typographers also believe that lowercase numbers are more beautiful and elegant than the ranging variety.

For over one hundred years, printers and typographers benefited from both sets of numbers, enabling them to use the appropriate set in any given application, but when typesetting was mechanized in the late nineteenth century, typographic variety was sacrificed for mechanical efficiency. Machine-set type had limited character sets that allowed for only one set of numbers. Some fonts (those text designs generally confined to what printers called "book work," which were books and pamphlets that required lengthy blocks of text copy) included the lowercase numerals design, while others (more general-purpose fonts used for "jobbing work," which consisted of commercial typography that required relatively little typesetting) had the ranging design. When phototype (also known as computer-set type) replaced machine-set metal type, the majority of foundries included only the ranging style in their fonts.

Lowercase numbers are sometimes described as "old style," recalling the time when lining figures were first introduced. Nineteenth-century typographers referred to the new type of numeral as "modern," relegating the already established lowercase numerals to the classification of "old style." To this day typographic traditionalists use this term to refer to the style of numbers found in Garamond's original font.

THE DESIGN OF THE NUMERALS

For the type designer, designing numerals can be a delicate balancing act. Because each numeral's base is either a round bowl or a thin single stroke, numerals do not have the natural baseline foundation from which most of the capital and lowercase letters benefit. Even in devising the relatively stable 2, the designer must maintain a delicate equilibrium between its full-bodied top bowl and baseline horizontal. While lowercase numbers reflect both the stroke weight and proportions of the lowercase letters, the stroke weight of the lining figures is usually slightly lighter than that of the capital letters.

In order to create the most beautiful and efficient characters, it is essential that designers bear in mind that the lineage of the numerals, like the lowercase letters, can be traced directly to calligraphic forms. While some liberties can be taken in the rendering of letters, numerals do not provide an opportunity for designers to exercise their creativity in the use of shape and proportion. Because individual letters are read within the context of their adjacent characters and words, which would compensate for a certain degree of design ambiguity, there is a little more latitude in the rules a designer must follow. Numbers, on the other hand, are almost always read singly, so that without the benefits of contextual relationships, each must stand on its own merits of legibility.

THE NUMERAL

1

This numeral almost always has flag or top serif. As it is particularly important in sans serif designs to distinguish the numeral 1 from the lowercase l, the flag is a holdover from calligraphic convention. In sans serif fonts like ITC Franklin Gothic, the 1 also has foot serifs. In lowercase designs, the 1 is equal to the x-height.

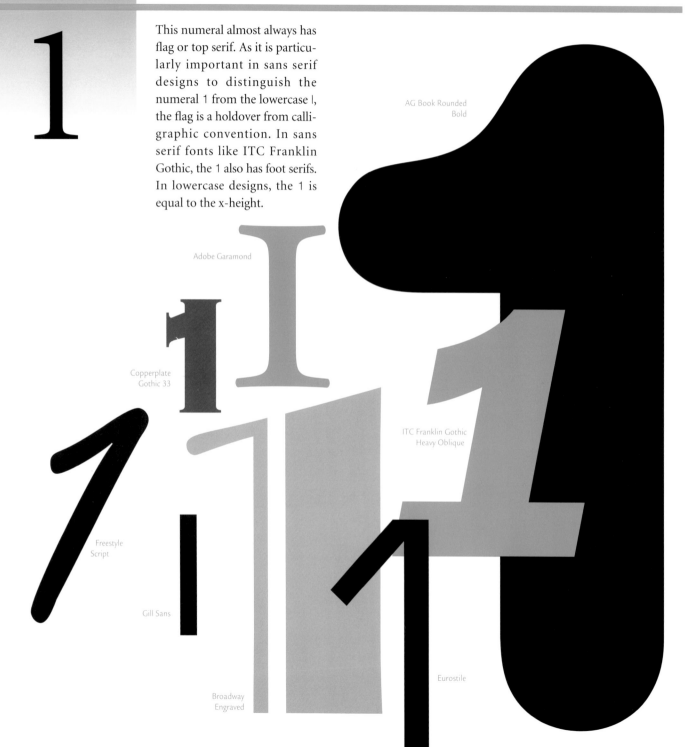

AG Book Rounded
Bold

Adobe Garamond

Copperplate
Gothic 33

ITC Franklin Gothic
Heavy Oblique

Freestyle
Script

Gill Sans

Broadway
Engraved

Eurostile

THE NUMERAL

2

The lowercase version of the 2 is a medial character; that is, it is the same height as the lowercase o and base aligns. Regardless of whether the baseline stroke is a straight horizontal or a curve that drops slightly below the baseline, it must be long enough to support the character optically. In some typefaces the top curve of the character ends with a ball- or pear-shaped terminal, and in a few rare examples it continues to make a complete, or nearly complete, circle.

Monotype
Onyx

Notre Dame

Utopia Black

ITC Grizzly

Madrone

Broadway

ITC American
Typewriter Medium

Helvetica Black

ITC Lubalin
Graph Book

THE NUMERAL

3

There are two varieties of 3. One consists of two connected semicircles, and the other is comprised of a horizontal top stroke linked to a bottom bowl by a short diagonal. (Some type designers believe that the latter is more "calligraphically correct.") Regardless of the differences between them, the bottoms of both characters must be strong enough to optically support the tops.

In roman fonts, the horizontal stroke of the second version usually ends in a serif. The top and bottom strokes (sometimes just the bottom) of the roman double-loop 3 end either in ball terminals or in subtle flares. The short diagonal of the calligraphic 3 is almost always a hairline stroke.

ITC Garamond
Light Italic

3

ITC Serif
Gothic Light

3

ITC Benguiat Bold

3

Diotima

3

Shelley Volante

3

Clarendon

3

Caslon Open Face

3

Baskerville

3

108

The Numeral

4

The 4 is made up of three strokes, the first of which is a vertical. If the numeral is an uppercase design, this stroke begins at the cap height and ends at the baseline. If it is a lowercase design, it begins at the x-height and ends slightly above the descender line.

The second stroke is a diagonal that begins at, and normally connects with, the top of the vertical. In some roman designs, however, the vertical stroke is shortened and the diagonal begins below the apex of the figure. If the character is true to the calligraphic model, the diagonal is a hairline stroke.

The third stroke is a horizontal, and its length is essential to the balance of the character. In lowercase designs it rests on the baseline, while in uppercase designs it is positioned at approximately one-fourth of the overall cap height. Sometimes the 4's horizontal terminates in a small serif.

ITC Mona Lisa Recut

Goudy Text

Bernhard Modern

Letraset Heliotype

Friz Quadrata

Variex

Bellevue

ITC Tiffany Heavy Italic

ITC Clearface

Futura

THE NUMERAL

5

The lowercase 5 is a descending figure. The calligraphic version is made up of four strokes: a vertical, a curve that begins at the bottom of the vertical, a completed bowl, and a horizontal that extends toward the right from the top of the vertical. In roman designs the vertical is usually a hairline stroke, and on occasion it is positioned at a slight angle. In some designs the horizontal is straight, and in others it is subtly curved. Note that the 5's horizontal is not necessarily the same weight or style as the 2's.

The shape of the bowl, which is critical to the 5's stability, is always fuller than the top portion of the character. The end of the bowl might flare slightly, as it would if it were drawn with a flat-tipped brush. It can also taper to a hairline, or end with a ball- or pear-shaped terminal. On rare occasions a serif also ends this stroke.

Latin Extra Condensed

Letraset Dolmen

Lithos

Caslon Open Face

Cloister Italic

Bauer Bodoni

Americana Extra Bold

Berthold City Bold

Adobe Caslon

ITC Bookman Demi

6

The uppercase and lowercase versions of the numeral 6 usually are the same size and share the same alignment. The approximate proportions of the lowercase o is a good starting point for the design of the bowl, but it can be either smaller or larger. In any event, the bowl of the 6 must be substantial enough to support the top of the figure, which might conclude in a refined taper, a ball or pear shape, or a slight flare that echoes the end of a square-tipped brushstroke.

Type designers must make several subtle adjustments to ensure that the 6 is balanced. First, the bowl should almost always be wider than the ascending stroke, and its base should always be slightly heavier than the top. Finally, the spine of the 6 must support the numeral's vertical orientation.

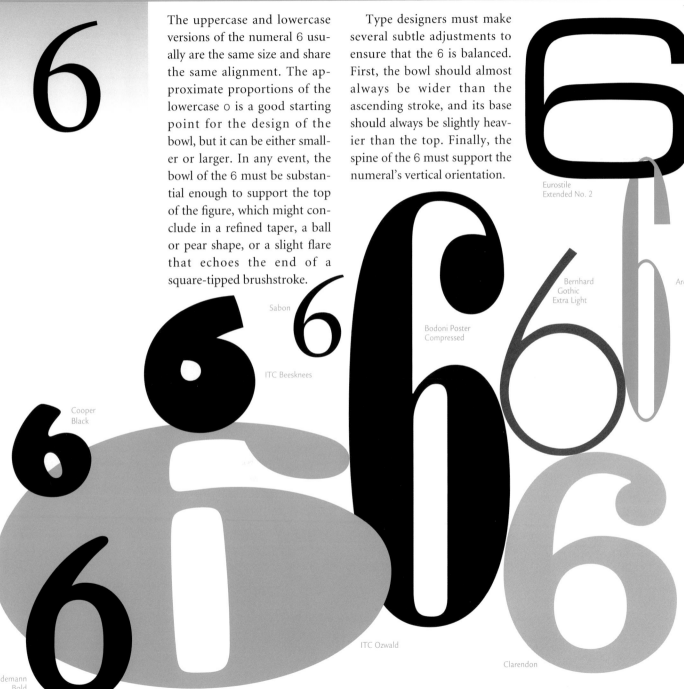

Eurostile
Extended No. 2

Sabon

ITC Beesknees

Cooper
Black

Bodoni Poster
Compressed

Bernhard
Gothic
Extra Light

Arcadia

ITC Ozwald

Clarendon

ITC Weidemann
Bold

THE NUMERAL

7

Requiring only two strokes of the calligrapher's brush, the design of the numeral 7 looks deceptively simple—deceptive because those two strokes must balance perfectly or the figure will look ungainly and unstable.

In the lowercase version the horizontal stroke is positioned at the mean line of the x-height, while in uppercase versions it aligns at the cap height. Sometimes the 7 will have a crossbar in order to distinguish it further from the 1.

The diagonal can either be straight or curved, and at times will have a serif or ball terminal at its base. Its angle is critical to the stability of the figure. If its orientation is too vertical, the 7 will appear to lean to the left; if it is too sharp, the figure will seem to fall over backward. In some fonts the top horizontal has a serif that also serves to help balance the figure.

Letraset Fashion Compressed

Futura Light

Letraset Heliotype

Industria Inline

Bellevue

Modula Black

Letraset Burlington

ITC Anna

Fette Fraktur

Notre Dame

112

THE NUMERAL

8

The 8 has the same proportions and alignment whether it is a lowercase or uppercase design, and its bottom bowl must be large enough to support the top one.

Except in the most geometric of sans serif alphabets, an 8 should never be designed as two circles, one on top of the other. The calligraphic version of the character is comprised of three strokes: a spine similar to an S's, with top and bottom strokes that curve back into it. In many designs the crossover of the top and bottom bowls created by these strokes is stepped; that is, the bottom bowl joins the spine at a higher point than the top bowl. Occasionally, one or both bowls remain only partially enclosed.

ITC Serif
Gothic Black

Poplar

ITC Avant
Garde Gothic
Extra Light

Letraset
Citation

Berthold City
Medium

Optima

Künstler Script
Medium

Broadway

Letraset
Follies

Monotype
Onyx

The Numeral

9

Despite first impressions, the numeral 9 is not an upside-down 6. The weights and proportions of the basic figure must be adjusted subtly to produce an optically correct character. For example, the bottom of the 6's bowl should reflect the maximum weight stress or spatial emphasis, while in the 9 it should carry the least. As for the 6, however, the spine of the 9 is key to its stability.

The lowercase version of the 9 is a descending figure.

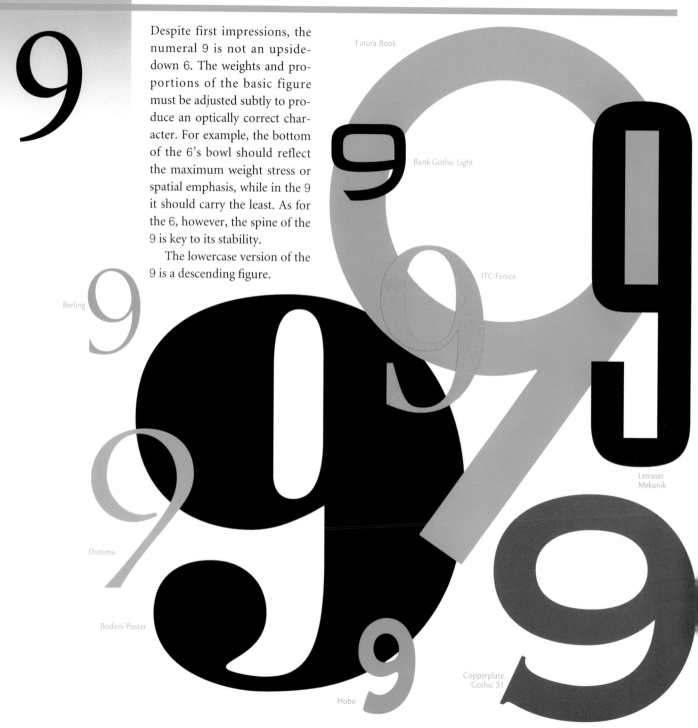

Futura Book

Bank Gothic Light

ITC Fenice

Berling

Diotima

Bodoni Poster

Letraset Mekanik

Copperplate Gothic 31

Hobo

The Numeral

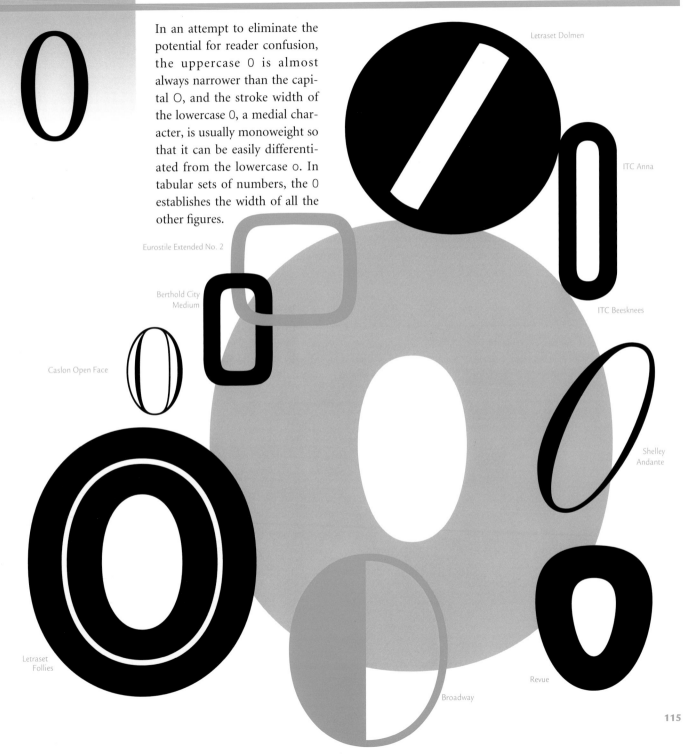

In an attempt to eliminate the potential for reader confusion, the uppercase 0 is almost always narrower than the capital O, and the stroke width of the lowercase 0, a medial character, is usually monoweight so that it can be easily differentiated from the lowercase o. In tabular sets of numbers, the 0 establishes the width of all the other figures.

Letraset Dolmen

ITC Anna

Eurostile Extended No. 2

Berthold City Medium

ITC Beesknees

Caslon Open Face

Shelley Andante

Letraset Follies

Revue

Broadway

PUNCTUATION

Lord Timothy Dexter wasn't really an aristocrat, but he was a shrewd businessman. He made a fortune by reclaiming at full value depreciated Continental currency that he had acquired during the Revolutionary War. As is evidenced by his inordinate affection for patrician titles, he was more than a little eccentric.

Dexter was also a writer of sorts. His best-known book is *A Pickle for the Knowing Ones,* which is remarkable only for its complete lack of punctuation. To its second edition Dexter added a page filled with periods, commas, semicolons, and other punctuation marks, so that readers could "pepper and salt it as they please." While it may seem that Dexter's disregard for proper punctuation was just another of his idiosyncrasies, it is absolutely in keeping with the heritage of our written language.

The earliest hieroglyphic and alphabetic inscriptions had no such symbols—no commas to indicate pauses, no periods between sentences—in fact, there weren't even spaces between words. Even the early Greek and Roman writers didn't use any form of punctuation. In later formal inscriptions, word divisions were indicated by a dot centered between words. Still later (probably out of expediency), spaces began to replace the dots. Gradually spaces between words became more popular, and by A.D. 600 the convention was quite common. In some early medieval manuscripts, the punctuation mark representing a full stop at the end of a sentence—two vertically aligned dots—looked just like our colon. Subsequently one of the dots was dropped, and the remaining dot served as a period, colon, or comma, depending on whether it was aligned with the top, middle, or base of the lowercase letters.

When the English scholar Alcuin established a consistent writing style for all scribes in the Holy Roman Empire in the ninth century A.D., the principal result was the Caroline minuscules, the forerunners of our own lowercase letters. Another important consequence of Alcuin's systematic approach to graphic communication was the first attempt at standardizing the marks and use of punctuation. Aldus Manutius, the Renaissance typographer and printer who was one of the first publishers to revive the works of classical Greek philosophers and who oversaw the design of the first italic letters, more firmly established Alcuin's reforms through consistent usage. Manutius used a period to indicate a full stop at the end of a sentence, and a diagonal slash to represent a pause.

The basic form of the question mark, which was once referred to as the "interrogative point," was developed much later, in sixteenth-century England. Most typographic historians contend that the design for the question mark was derived from an abbreviation of the Latin word *quaestio,* which simply means "what." At first this symbol consisted of a capital Q atop a lowercase o. Over time this early logotype was simplified to the mark we use today.

In the seventeenth and eighteenth centuries, quotation marks, the apostrophe, the dash, and the exclamation point became part of the basic set of generally accepted and consistently used punctuation marks. The initial configuration of the exclamation point (referred to as a "bang" or a "screamer" by old-time printers), which is also descended from a logotype for a Latin word, io ("joy"), was a capital I set over a lowercase o. Gradually, as with the question mark, the design of the exclamation point was reduced to its present form.

Our repertoire of punctuation continues to expand today. As recently as the 1960s, a new mark, the interrobang, a ligature of the exclamation point and question mark, was suggested to punctuate sentences like, "You did what?!"

PUNCTUATION DESIGN

The type designer must keep in mind that punctuation marks are an integral part of a typeface design. They should not be treated as separate pi characters or as standard forms that can be thoughtlessly combined with each and every type design. For instance, the question mark in ITC Anna simply wouldn't work with typefaces like ITC Highlander or ITC New Baskerville, and even the humble period from ITC Tiepolo would look completely out of place with a design like ITC Franklin Gothic or ITC Fenice.

THE PERIOD

In a roman design, periods are usually rounded forms, while in sans serif faces they can be round, square, or rectangular, depending on the design and proportions of the typeface. In alphabets that reflect a calligraphic influence, periods are often diamond-shaped.

The weight of the period is a critical design decision for two reasons: first, because it establishes the weight for many of the other punctuation marks; second, because it must be heavy enough to be easily noticed, but not so massive that it is conspicuous within a page of text.

ITC Mona Lisa Recut

Cosmos Extra Bold

Letraset La Bamba

Letraset Citation

Goudy Old Style

Letraset Follies

Helvetica Black

Arcadia

Ironwood

Bovine Poster

THE COMMA

The top of the comma usually repeats or is similar to the contour of the period, and its dangling curve or flared hook is generally a stroke, reminiscent of a pen flick, that points toward the left. In sans serif designs the comma might be a simple parallelogram, as can be seen in ITC Avant Garde Gothic, or it could follow the roman model, which is evident in ITC Franklin Gothic.

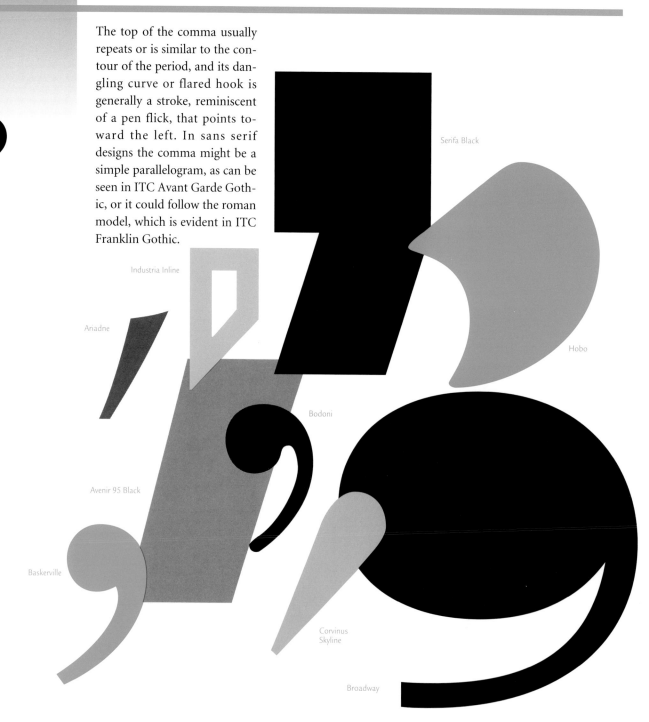

Serifa Black

Industria Inline

Ariadne

Hobo

Bodoni

Avenir 95 Black

Baskerville

Corvinus
Skyline

Broadway

The Colon

The colon usually duplicates the design of the period, but in some typefaces the dots are smaller. While the bottom dot aligns with the bottom of the period, the alignment of the top dot depends on the colon's design. The top dot generally aligns with the mean line of the x-height, though occasionally it is slightly lower. The colon's determining design criterion is that it looks appropriate with the lowercase letters.

Cooper Black

Neue Neuland Inline

Barmeno Extra Bold Italic

ITC Kabel Bold

Letraset Dolmen

Bank Gothic Medium

THE SEMICOLON

The semicolon's dot is the same design and alignment as that of the colon. Its comma usually aligns with the standard comma, but it is not always identical in size or design.

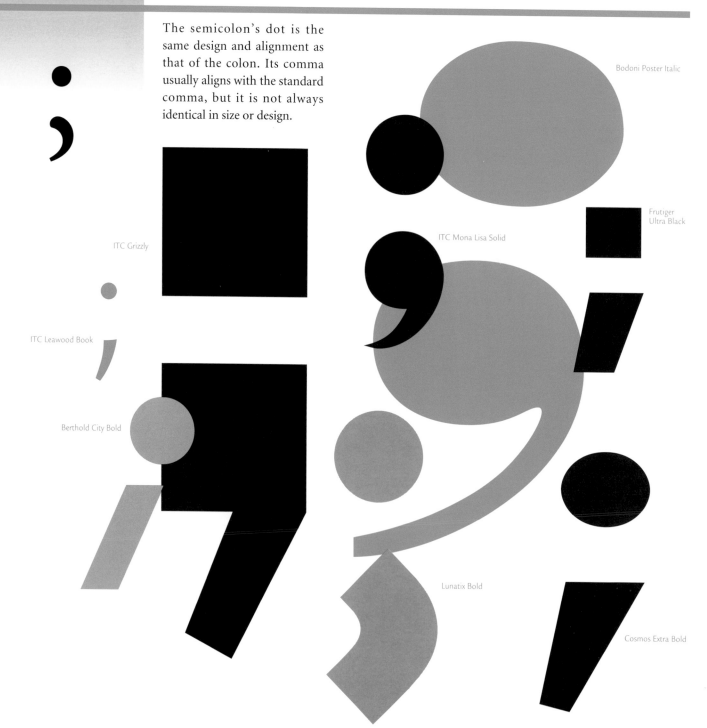

Bodoni Poster Italic

Frutiger Ultra Black

ITC Grizzly

ITC Mona Lisa Solid

ITC Leawood Book

Berthold City Bold

Lunatix Bold

Cosmos Extra Bold

THE EXCLAMATION POINT

The dot at this character's base either aligns with the period or is centered on its height. In some typefaces, especially those with strong calligraphic or old style influences, the period is heavier than the dots used in characters like the exclamation point, question mark, or colon. The top of the stroke ordinarily aligns with the cap height, or falls just slightly below it.

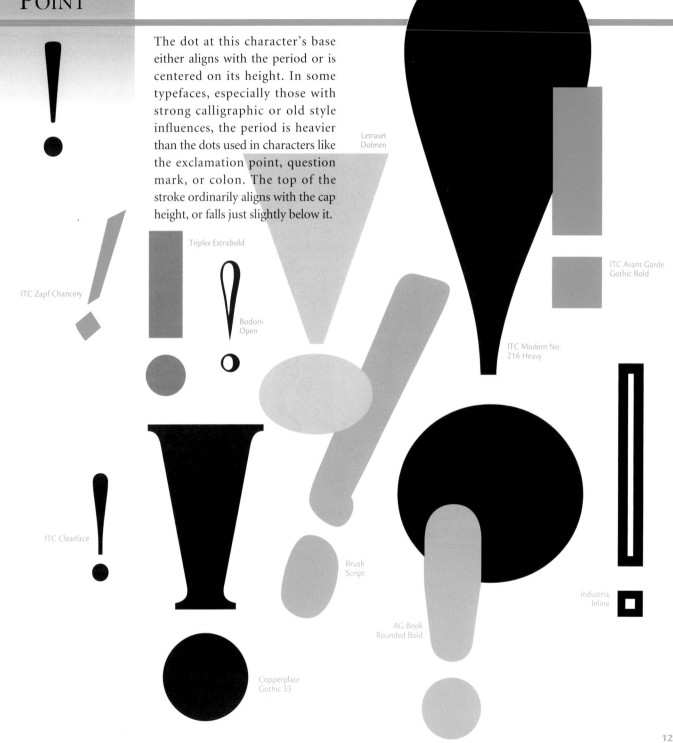

ITC Zapf Chancery

Triplex Extrabold

Bodoni Open

ITC Clearface

Letraset Dolmen

ITC Modern No. 216 Heavy

ITC Avant Garde Gothic Bold

Brush Script

AG Book Rounded Bold

Industria Inline

Copperplate Gothic 33

THE QUESTION MARK

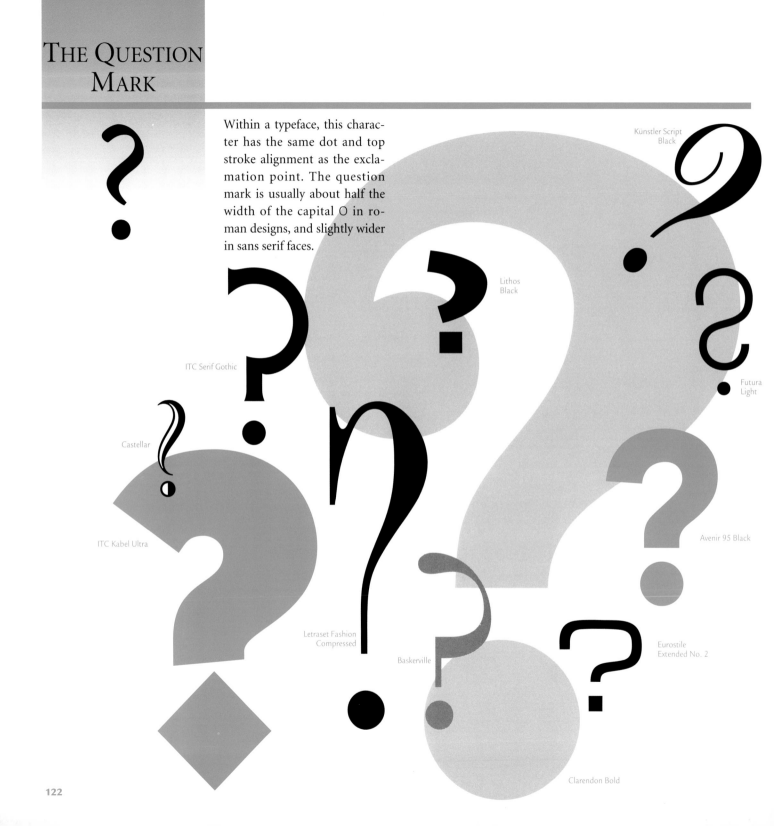

Within a typeface, this character has the same dot and top stroke alignment as the exclamation point. The question mark is usually about half the width of the capital O in roman designs, and slightly wider in sans serif faces.

Künstler Script Black

Lithos Black

ITC Serif Gothic

Castellar

Futura Light

ITC Kabel Ultra

Avenir 95 Black

Letraset Fashion Compressed

Baskerville

Eurostile Extended No. 2

Clarendon Bold

QUOTATION MARKS

An opening quotation mark looks like an upside-down comma (although in some typefaces it is slightly smaller), and the closing quotation mark is usually just a rotated version of the opening quote. Rounded quotation marks usually align with the cap O, and squared ones with the capital H, but there are exceptions. Sometimes the opening quotation mark, which is almost always followed by a capital letter, is positioned slightly higher than the closing one so that they will appear to align at the same height. Occasionally, as in old style type designs whose lower-case ascenders are taller than the capitals, the quotation marks will align with, or are positioned slightly below, the ascenders.

ITC Ozwald

Albertus

Aachen Bold

Linoscript

Helvetica Bold

Letraset Follies

Hobo

Ariadne

Ponderosa

Bauer
Bodoni

Smaragd

Fette Fraktur

SUBJECT INDEX

INDEX TO TYPEFACES

The name of each typeface that illustrates this book is followed by the name of its foundry or original source, which is enclosed in parentheses.

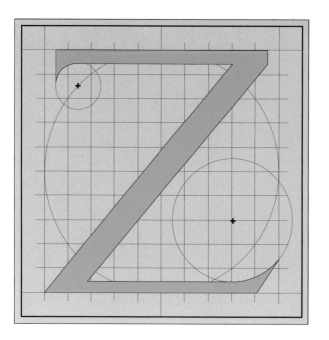

The text of this book is set in Minion, a digital type family
designed for Adobe Systems, Inc. by Robert Slimbach.